How To Photograph the Outdoors
in Black and White

George Schaub

STACKPOLE
BOOKS

To Grace, and the trails
we've traveled together.

Copyright © 1999 by Stackpole Books

Published by
STACKPOLE BOOKS
5067 Ritter Road
Mechanicsburg, PA 17055
www.stackpolebooks.com

Printed in the United States of America

First edition

10 9 8 7 6 5 4 3 2 1

Cover design by Wendy Reynolds

Library of Congress Cataloging-in-Publication Data

Schaub, George
 How to photograph the outdoors in black and white / George
Schaub.— 1st ed.
 p. cm.
 Includes bibliographical references (p.).
 ISBN 0-8117-2450-6
 1. Outdoor photography—Amateurs' manuals. I. Title.
TR659.5.S33 1999
778.7'1—dc21 98-8289
 CIP

CONTENTS

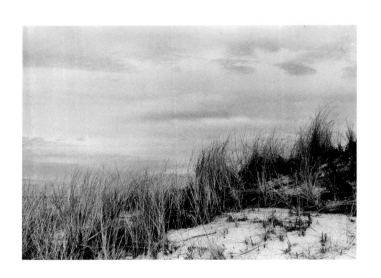

The LaJunta trailhead starts atop a flat plain that halts abruptly at the edge of the Rio Grande Valley rift. The rift wall to the west is strewn with boulders and dotted with juniper, sage, and pinion; farther west the land stretches in a sloping plain, with thunderheads forming in the afternoon heat. To the east the monumental Sangre de Cristo range catches the clouds; in the foreground a vast sage field shimmers in the light. As we look over the edge of the wall, hawks and ravens circle above the confluence of the Red River and Rio Grande. The trail beckons.

The plan is to start down in the afternoon light and walk to the edge of the Rio Grande. We'll follow the riverside trail until we get to the Big Arsenic cutoff, then head back up when the steep incline starts to get shadow. We'll chase the light of the declining sun up the westward-facing embankments, getting the most out of its direction and strength.

Before embarking we check our gear. The tripod is strapped with a shoulder harness; a shoulder strap with the requisite quart of spring water gets slung along with the tripod. We open our backpack and check our photographic supplies. There are four rolls of thirty-six-exposure ISO 100 black-and-white film and two rolls of ISO 400 film. We start with a roll of infrared film loaded in the camera. There's a 24mm lens on the camera body, with a 180mm and a 35–105mm zoom as extras. A rubberized air blower and lens cleaner is packed in case the wind kicks up dust, which is a good possibility, as the setting sun usually sets off vectors from inside the valley. There's also a set of filters—red and orange, along with a polarizer—to enhance the sky and deal with reflections that play off the river.

While not every photographic sojourn takes place in such a glorious spot, the thrill of working outdoors, with its changing light and moods and amazing variety of subject matter, is what makes the craft of photography worthwhile. Having a camera in hand makes us instant observers, and the smallest detail opens our eyes to the miracles of life and the intricacies of nature's creative hand.

Even those who do not practice a formal religion cannot help but be moved by what photographing outdoors can reveal. There are patterns, designs, and forms and, of course, the glories of light. There are unpredictability and surprise and challenges that force us to deal with the materials of our craft. There is also the deep satisfaction of capturing those moments and scenes that move us, that allow us to communicate our appreciation and awe of the world.

I have been photographing for almost thirty years and have done everything from weddings to corporate brochures to illustrative images for travel and technical mag-

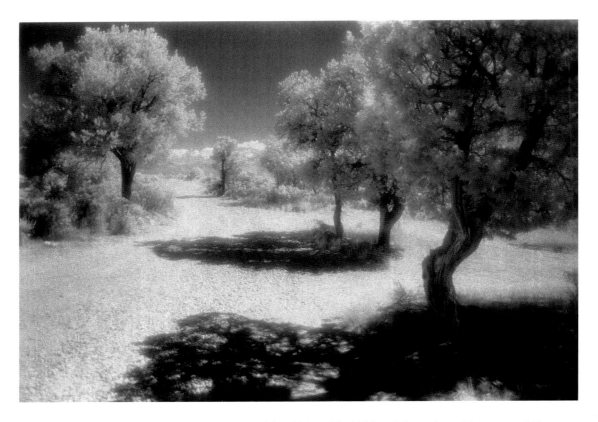

Rim section, LaJunta trail, New Mexico, 1997. *Nikon F3, Nikkor 24mm lens. Exposure: f/8 at 1/60 second.*

This shot was made on Kodak infrared black-and-white film (rated at EI 64) with a red filter over the camera lens. Infrared is a special-effects film that can be used to create a dreamlike, almost surreal sense of place. Here, the film causes trees to glow, the sky to darken, and shadows to become stark and opaque. Not every scene benefits from the use of infrared, but it certainly is a fascinating effect.

azine articles. Photography has provided a good living for me and my family. But I hold a special place in my heart for outdoor work, especially in black and white. It is in that realm where I find the most satisfaction and where my craft is freed to fully express what I feel about and see in the world. It has also helped me explore regions and ideas that would otherwise have been dormant or that would never have been fully realized in my other photographic work.

It is my goal in this book to share that joy with you and to lend my experience to help you appreciate the wonders of this medium and craft. My approach involves seeing and then translating that perception through the medium. It is at times necessarily technical, but only so far as it serves visual expression. It is mostly about opening up possibilities and potential and encouraging you to give it a try.

Now let's hit that trail.

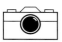

An Appreciation of the Medium
The Beauty of Black and White

What is it about black and white that makes it such a compelling medium for the outdoor and nature photographer? In terms of pure visual enjoyment, there is the beauty of the tonal values—the shades of gray, deep blacks, and bright whites—which offer a unique expression of the play of light and shadow. The tones are versatile and can be made to represent with equal power both the hard glint of light off freshly fallen snow and the soft, diffuse light rising from a fog-bound river valley on a summer morn.

Black and white allows us to visualize without the distraction of color. This permits us to approach the heart of a subject or natural design in its purest form. It also gives creative freedom, as the artistic intent of the photographer can be applied in every step toward the final creation of the image, from the way in which we see and interpret the subject to the choice of film, exposure, processing, and printing. This should not be taken as a matter of color versus black and white; rather, it is a matter of appreciating the artistic pleasure that black and white affords and understanding the visual dynamics that make it work.

Each step of creation offers many variations, each of which can lead down different paths, and each path can yield a choice of visual expression. Knowing the options is important; knowing how to apply them to the image at hand is equally important. As you grow in your experience of both technical and aesthetic matters, you'll find new and exciting ways to render the world around you.

Black and White: The Expressive Medium

For those who love photography, black and white has always been a source of meaningful expression. A study of the work of the medium's masters—from Ansel Adams to Edward Weston to Minor White—reveals the potential of its visual power. The range of expression that these and other photographers evoke and the rich tradition of the medium help explain its diversity and appeal.

An important aspect of black-and-white photography is its power of interpretation, the ability to blend your way of seeing with the scene or subject matter at hand. When shooting landscapes, for example, the aim is to communicate a sense of place. The techniques you apply define both the objective place (the record of that scene) and your perceptions and feelings about it. Depending on your decisions, you can create an image of the scene pervaded by light and contrast or one set in deep, dark tones. The objective place does not change; what you can change is your interpretation, the

1

way the scene is altered by journeying through your mind's eye.

Consider a tree on the edge of a cliff overlooking a churning sea. The tree's leaves have been stripped by the relentless wind; its branches tell a story written by the energy of the forces around it. You have before you an objective scene—the tree, rocks, and surf—but you also have the power to enhance the mood in any fashion you desire. Through exposure, development, and printing choices, you can make the tree stand out in contrast with its surroundings, thus accentuating its presence and power, or you can have it enveloped by its environment, thus creating a deep, moody blend throughout the entire scene.

Among the towering dunes in White Sands National Monument, the magical forms shaped by the wind offer a tantalizing array of design and texture. After spending the latter part of the day photographing, entranced by the always-changing light, we look over our results and begin to interpret what has been recorded. In one version, we re-create what was seen with a faithful rendition of tonal play; in another, we alter the print to soften the play of light, thus blending sky and ground; in yet another print, we accentuate the difference between sky and ground and create an image in which each grain of sand seems to stand out as part of the whole.

The ability to enhance the image is one of the powers granted to all photographers.

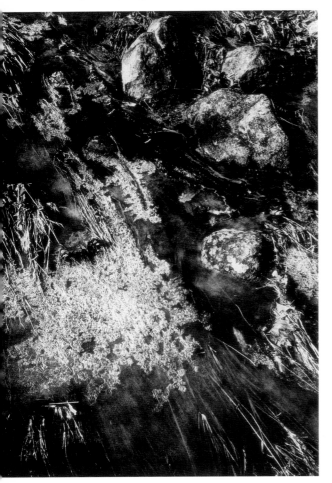

Black and white has many moods, offering a wide variety of expression. These three shots show just some of the possibilities. Left: This frozen streambed is rendered in fairly high contrast; frost glistens on a glaze of surface ice, with details of the rocks and leaves emerging from the shadows. The subject is interpreted through contrast rendition and becomes a study in line, form, and design. The image was exposed normally; the high-contrast version was created during printing. Top right: Spring blossoms evoke a feeling of light and life. This delicate rendition was made possible through slight overexposure in the camera and a low-contrast printing choice. Bottom right: The subtle differentiation in tonal values was captured in this scene on Elba, made possible through careful exposure readings that balance the light and shadow on film. Shadows remain "open" (show detail), while the highlights (the white wall and fence) retain their stucco texture. The print captures the quality of light in the scene and evokes a true sense of place.

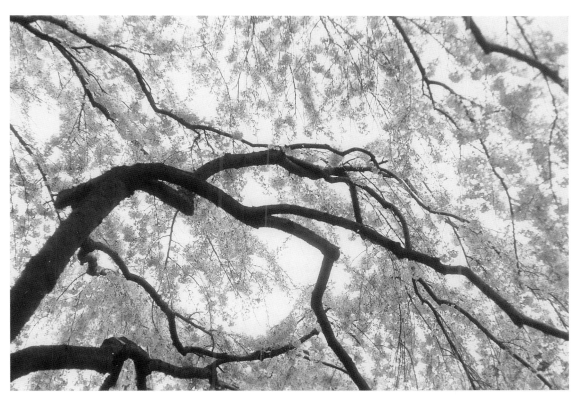

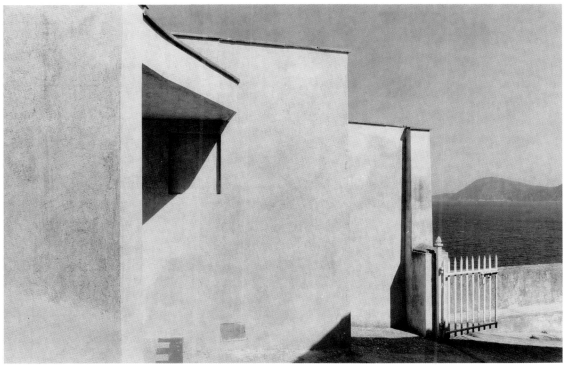

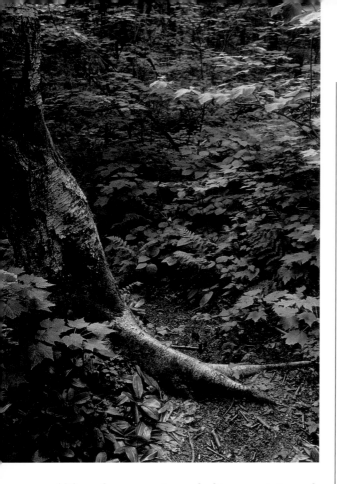

A sense of place—the emotional connection in an image that evokes a time, location, and feeling—can be achieved in many ways. Techniques of exposure, printing, and composition are key; understanding how they can be most effectively applied and having a mindset that brings them together in a personal statement make it work. This photograph was made in Jamaica State Park in Vermont. The rain had just stopped, and bright overcast was just beginning to penetrate the canopy onto the forest floor. The deep, lush quality of the setting is echoed in the print.

Although we are grounded in a certain reality by photography itself, we share with painters the freedom to interpret the light and scene in any way we desire. Subjects can be manipulated by film, exposure, processing, and printing choices; the visual essence of the moment can be distilled by the photographer through a variety of techniques, including the new world offered by computer imaging. The final print or image becomes a remembrance of the objective scene as interpreted through the artistic eye of the individual photographer.

Indeed, the most expressive black-and-white images are often reinterpretations of the moment, realized by the photographer's exploration of the possibilities. With focused energy, the image becomes a vehicle for a deeper consciousness of light and form, and the subject opens up layers of visual mean-

ing. The process through which this is achieved combines technique with artistic intuition; it requires some contemplation and the commitment to go a step beyond what was first glimpsed when the shutter was released.

Although abstraction and special effects have their charms, a basic understanding of the principles of photography and how they can be creatively applied is what separates luck from purposeful intention. And that intention is the beginning of art. That's not art with a capital *A*, but the kind of art that opens us up to the possibilities of personal expression.

One good way to start is to learn to re-create on film and print the quality of light that appeared in the original scene. The basics include understanding how light records on film and how proper exposure techniques yield a faithful rendition of the scene. From there, you can begin to explore ways in which the moment can be transformed and the vision enhanced.

Photography is a blend of art and science, of intuition and analysis; it's the classic right-brain, left-brain activity. It is also a medium in which the tension between the two becomes resolved: The science is there to serve the art, and the art can only be truly realized through an application of the

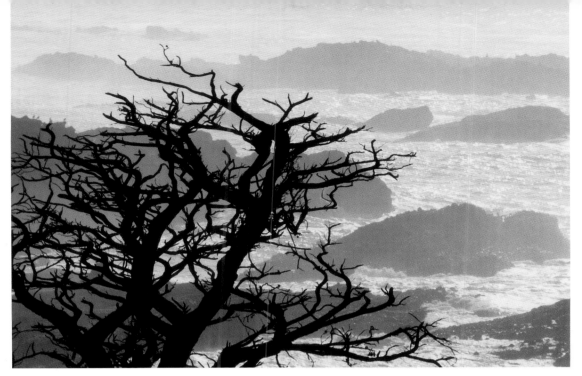

Even after the photograph is exposed, you can enhance the image further through printing choices, performed by you or a lab. This scene was captured near Carmel, California, with a 300mm lens on a Nikon N8008 35mm SLR mounted on a tripod. Exposure of the Ilford Delta 400 film was f/8 at 1/30 second. These two renditions are printed from the same negative. The lighter version causes the tree to stand out from the background; the darker one changes the entire feeling of light, mood, and context. The difference in technique is longer exposure time of the print in the darkroom.

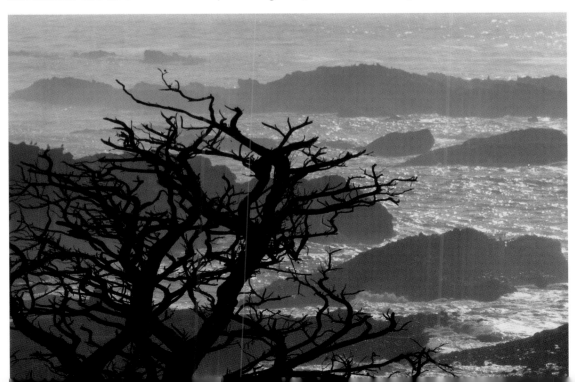

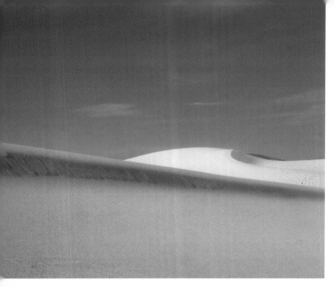

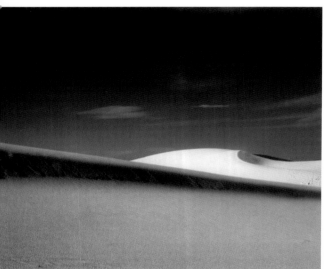

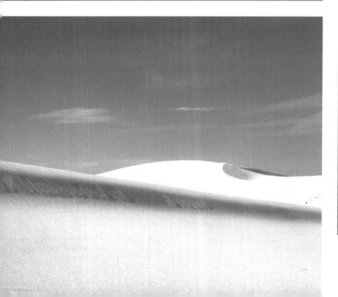

science. Happily, much of the science is made easy with modern cameras, meters, and film, but these can take you only so far. It is in the exploration of the art that the real experience takes place, where your expression of the world is made truly manifest.

Tonality and Texture

When we discuss the visual attributes of a black-and-white image, we often refer to its tonality. To describe an image as black and white is a bit of a misuse of terms; it is instead an image that relies on shades of gray that range from deep black to pure white and all the values in between.

This range is referred to as a gray scale and can be visualized as a series of steps, or tonal differences, that lead from black to white. When we work in black and white, we are recording the range of gray-scale values within the scene—the lights and darks that define the subject. In the scene, we refer to these differences as brightness values; in the recorded image, we refer to these differences as tonal values. Although the color of the various subjects within the scene influences the tonality, it is the brightness of that color, rather than its redness or blueness, to which the black-and-white photographer responds. In analytical terms, we are

Subtle interpretations form visual clues that key different responses in us all. Reality in a photograph is run through the imagination of the photographer. This photograph was made with a Pentax 6×7 medium-format camera in White Sands National Monument. From the same negative we can create a faithful rendering of the tonal values (top), a higher-contrast version that emphasizes form and design (middle), or a lighter version that alters the balance of light as it originally appeared in the scene (bottom). What's the best choice? It's whatever satisfies your creative desires.

Exposure translates the brightness values in the scene—the range of lights and darks—to tonal values on the film—the various shades of gray plus black and white. This scene, made on the banks of the Battenkill River in New York State, covers a full range, from the bright white of the fence to the deep black of the shadows in the background. Lighter and darker grays define the forms; their tonal values and the borders between them help create texture and visual information. The interplay of shadow and light forms a visual impression of the subject seen through the viewfinder. The gray scale is what allows us to differentiate one brightness value from another.

dealing with the luminance rather than the hue of the reflected light before us.

Lighting emphasizes the subject's texture, with its surface sheen, deep shadows, and subtle movement from dark to light. In black and white, a smooth surface may read as bright white; shadow may read as black. But as you'll see, the way brightness values translate is subject not only to the lighting conditions and the subject at hand but also

to the way in which the image is exposed. The range of tones defines the image; the tonal borders (the edges between tonal values) and deep shadows define the form and shape of the subject.

Unfocused, a scene would read as a collection of blacks, whites, and various shades of gray. When sharply defined, the collection of tones creates an illusion that re-creates the subject in the mind's eye. A

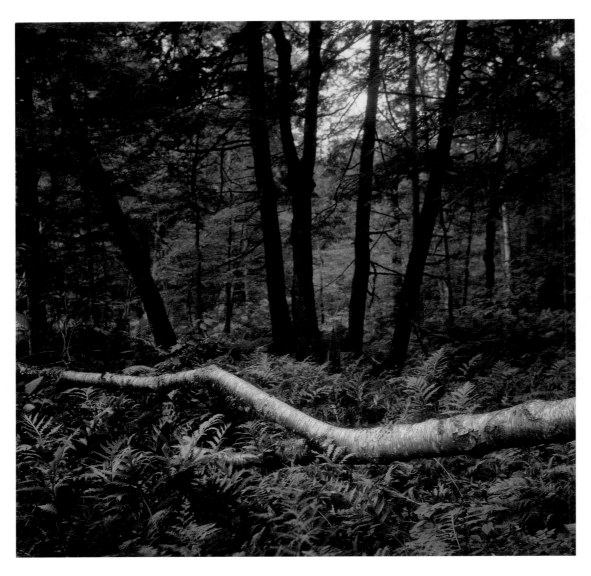

The light in this scene from Tongue Mountain trail near Lake George, New York, has been altered through exposure and development. Exposed on Ilford Delta 100 film with a Rollei medium-format camera, the original scene was pervaded with an even, bright light. Exposure was made to capture all the available tonal values. In the darkroom, a technique known as "burning in," which applies extra exposure to selected areas of the print, was used to darken everything but the fallen tree and a circle of center light in the foreground. This enhanced the glow of light on the bark and changed the feeling of the image. Seeing the potential in each image and exposing and printing to creatively enhance it is one of the true creative tools of the craft.

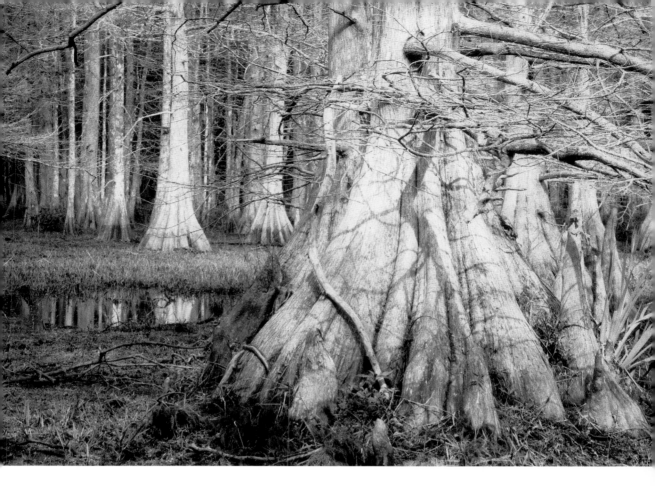

This uncorrected print of a cypress swamp in the Florida Everglades illustrates what the raw image looks like when exposure is made for the shadows. The brighter parts of the scene (the highlights) read f/16; the deeper parts of the swamp read f/2.8. When exposed at the f/2.8 setting, the highlights "burn up" and record much brighter than desired, thus overexposing the scene. However, note the open quality of the dark shadow area. This imbalance can be corrected, to a certain extent, when a final print is made.

color photograph renders the subject in hues and all their nuances; a black-and-white image works with white, light and dark grays, and black.

Thus, tonality is the image record of the levels of light reflected from a subject; when rendered on film, it reads as a relationship of gray values that define an image. Color enters the equation only in terms of its brightness value: A deep red sandstone *may* record as black, a bright blue sky *may* record as dark gray, the leaves on a tree *may*

record as light gray, and an adobe wall *may* record as near-white. I emphasize the "may" because tonality is directly related to exposure, and exposure determines how the tonal values are arrayed on the film record. As you'll see, the ability to shift the relationship of tones is what aids the power of interpretation.

For example, say that we are photographing a forest floor, with dappled light coming through the tree canopy. Depending on how we expose and print that image, we can cre-

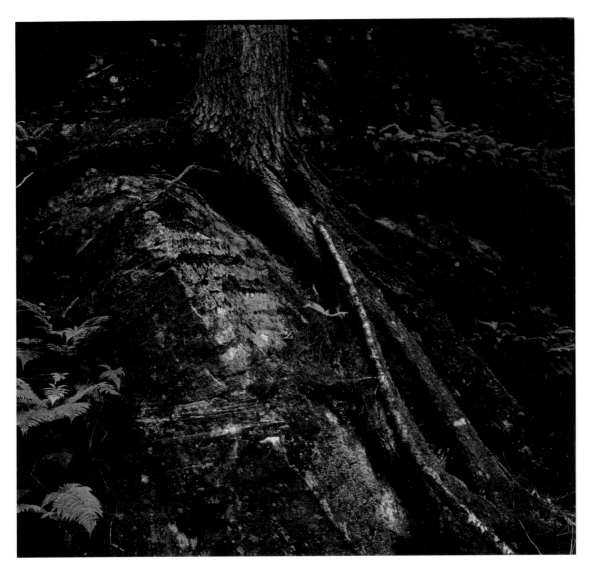

This print of a tree root surrounding a rock, made in Harriman Park, New York, illustrates under-exposure. Insufficient exposure caused a loss of shadow detail, or tonal information, in the darker parts of the scene. This can be corrected to a certain extent, but no detail can be salvaged from the darker areas, as the "blank" areas of film hold no information at all. Thus, these blank, or "thin," areas on the negative record as deep tones (black and deep gray) but will yield no texture or detail.

ate a print set in deep, dark tones, with details barely emerging from the shadows, or we can create an openly lit rendition with bright, hot highlights marking where the sun falls. This interpretation of tonality is key to the communication of emotion and mood in the scene and is one of the sources of the power of the black-and-white medium.

When film is exposed, the tones work in a sort of lockstep—that is, how you expose the film determines the scale and range of the recorded tones. In some cases, you might expose to emphasize shadow details—that is, the darker parts of the scene in which you want to record detail. While you do "open" the shadows to light, you also add more exposure to the brighter parts of the scene. The consequence is that these bright areas might record brighter on film than they appeared in the scene. This overexposure can be adjusted, to an extent, when a print is made. If you expose the film so that the brighter parts of the scene record with detail and texture, the darker parts might become underexposed and, depending on the degree of underexposure, might not record on the film. A tonal value would record but would not hold visual information; thus, the shadow areas would appear black or very dark gray.

The limits of your ability to record both bright and dark parts of a scene on film are in the nature of the medium and are subject to the lighting conditions at hand. When the eye looks at a scene, it scans around, and the pupil dilates and constricts to adjust for the changes in brightness values, or intensities of light. Camera and film "look" at the whole scene with one fixed stare; they cannot adjust for contrast, or differences in light value, in select portions. (If the medium could do this, photography would be a much simpler matter.)

Thus, exposure is key to successful photography. The purpose of light metering is to define the range of light recording and to

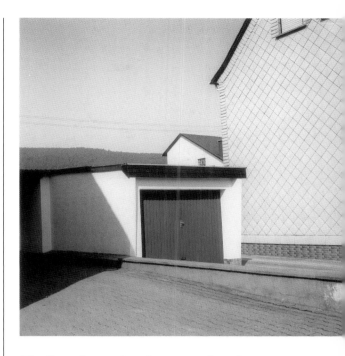

The Zone System breaks gray-scale values into ten zones. Those who explore tonality will find many more nuances, but relating how light and film interact using this system can be helpful. Note the range of light to dark in this scene, made in Piesport, Germany, with a Rollei medium-format camera on T-Max 100 film. The brightest white would be considered zone 8, and the deepest shadow with visual information would be called zone 3. The lighter gray wall is about zone 6, and the middle gray of the sidewalk is about zone 5.

find the best compromise exposure that will properly arrange the various lights and darks in the scene on the recording scale of the film.

Although this may seem to limit the possibilities, black-and-white film has a fairly broad range of light-recording ability—in fact, due to other controls, it has the broadest range of any photographic medium and has real trouble only with high-contrast

Tonal scale can be played with to express different moods and enhance the visual impact of an image. There are many nuances, but the rough division is full scale, high key, low key, and high contrast. A full-scale print (left) attempts to capture the full potential of the tonal richness in the scene. It usually displays the full gray scale (or as much as possible, given the lighting conditions) and is accomplished by careful exposure, development, and printing. This scene was made in Valley of Fire State Park in Nevada and faithfully displays the range of tonal values in the rock and weed. A high-key impression works with the lighter shades of gray (bottom). High-key images usually contain very little deep black and count on a degree of negative overexposure to open up shadow areas; a lighter-than-normal print can be made on low-contrast paper. The scene was made during a snowstorm in

Mattituck, Long Island. A low-key image (below) is a moody rendition of a scene that can utilize underexposure (though that's not always necessary, given the proper lighting and subject); a darker-than-normal print can be made on a normal or low-contrast paper. These ice flows off Sea Cliff, Long Island, were photographed on a heavily overcast day. Printing them dark created an abstract impression of the scene. High contrast is a tonal compression that relies on deep black and bright whites in the original scene, though any scene can be rendered as high contrast by using special printing papers and techniques. This skull (next page), photographed outside Espanola, New Mexico, was considerably brighter than the ristras surrounding it. The already high-contrast negative was enhanced by printing on high-contrast paper. The stark subject matter lent itself to this rendition.

scenes. You also can adjust for reasonable over- and underexposure and even recover tonal information in very bright or somewhat dark areas later when prints are made. These adjustments are discussed in Part Five. For now, keep in mind that the range of tonal values you record is directly tied to exposure and that you can interpret the image by way of tonal manipulations in exposure, development, and printing techniques.

You may have heard something about the Zone System. This is an attempt to simplify the gray scale into ten steps, called zones, that go from deep black to bright white. Zone 0 is deep black, zone 3 is dark gray with detail, zone 5 is middle gray (the midpoint between white and black), zone 8 is near-white with texture, and zone 9 is bright (textureless) white. If it helps, you can think of the gray scale in this fashion. The Zone System, propounded by Ansel

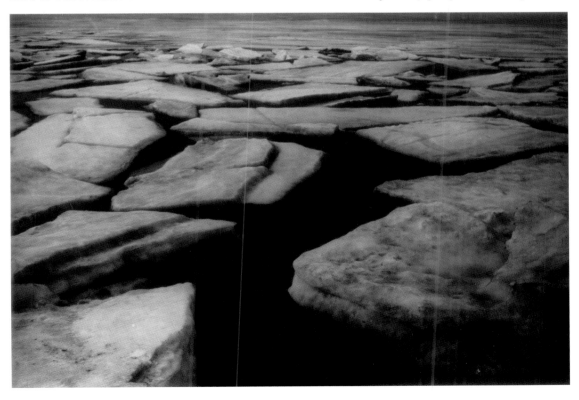

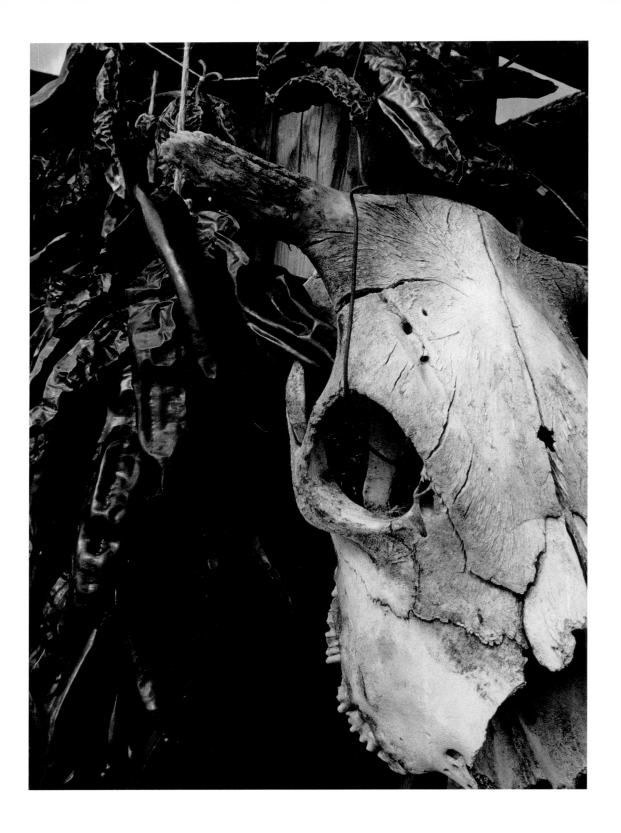

Adams and others, also involves a system of tonal placement, manipulated development, and previsualization that can be revelatory but often confusing for many photographers. (You can read any number of books on the subject, including *The Negative* by Ansel Adams.)

Although the Zone System "works," it too often embroils those attempting to unravel its mysteries in excessive contemplation of numbers at the expense of vision. If taken as a point of reference and a way to relate light and film, it can be helpful. The use of modern films and an understanding of some basic principles and a few techniques can achieve similar results; there's no shortcut to obtaining good results, but you can do quite well without passing through the Zone System academy.

You can describe the overall impression of an image by way of its tonal range. A full-scale, or tonally rich, image is one in which the original brightness values in the scene are faithfully rendered on film, a feat accomplished through careful exposure and printing procedures. A high-key image is one that utilizes the lighter shades of gray and white for its communicative power. A low-key image is one that works with the darker grays and blacks for its impact. In a high-contrast image, the tonal values are compressed, resulting in a visual record in which blacks and whites, rather than grays, play the major role. Each rendition has its own charms and visual rewards. The exciting aspect of all this is that you can play each variation each time you make a picture. Of course, some subjects lend them-

Texture defines this scene, with the play of light giving us visual clues that allow us to touch and feel the subject. Each part of this image, be it the horno oven, the wooden board, or the walls of the adobe structure, has a distinct visual texture that is translated through the play of shadow, light, and tonality. This photograph was made with a Nikon F3 camera with a 24mm lens, exposed on Tri-X 400 film at f/11 at 1/125 second.

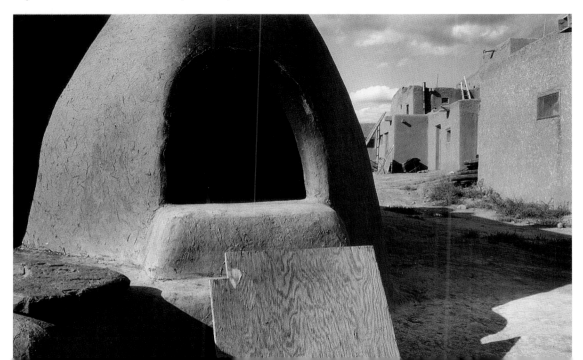

selves to a certain treatment, but this is a matter of taste and experience.

You may have noticed that similar terms are used in both photography and music. This is no accident. Photography and music both have a scale, tone, and key and can be played in various tempos and moods. Both serve as a direct, nonverbal route to intellect and emotion. Thinking of one as an expression for the ears and the other as an expression for the eyes opens up some intriguing possibilities.

Whereas tonality is the record of brightness values, texture, or image information, is the visual detail contained within those tones. Picture an adobe structure in bright, midday light. The play of light defines the shapes and surface textures of the subject. The sky is deep blue and, having no texture, records as a field of deep gray. The clouds have a range of values and record from bright white to mid-gray, with the surrounding sky defining their forms. The adobe walls have a defining surface, which is depicted as a middle gray. The shadows are deep and record as textureless black. The ground on which the shadows fall is a very light gray, showing the rocks and sand that we can almost hear crunching under our feet as we walk through the picture.

Why do some parts of the scene record with texture and others do not? First, texture is image dependent; that is, if there is no texture in the subject, none will record—that's what happened with the sky in the above scene. But texture is also dependent on how specific areas are exposed and how the tones array themselves within the recording range of the film.

There are a few terms that help define how tones and their visual content work; these include highlight, spectral highlight, middle values, significant shadow, and deep shadow. The highlight is the brightest part of the scene in which texture is recorded. For example, when photographing light reflecting off water, the brightest area of the scene in which we can "read" the water as having surface texture is the highlight. The part of the scene where the sunlight glints off the water is the spectral highlight; this may read as "paper" white—that is, there is no texture, just bright light. The darkest areas in which we can see the surface texture of the water is called the significant shadow. The areas where we see shape but no texture is the deep shadow, which reads as either black or very dark gray. The middle value is that which sits between the highlight and the significant shadow. It is the fulcrum that balances the exposure and determines how the other values will record.

Your camera or handheld meter takes all the brightness values it "sees" and averages them to that middle gray zone 5, or the gray that sits directly in the middle of the scale from black to white. In essence, this distributes the brightness values correctly so that they record on the film as they appeared in the scene. Their relationship to one another is established by averaging and then distribution on the film's recording scale.

This is one of the keys to successful black-and-white photography: understanding the way film records and how your meter reads the scene. Once you get a handle on these important matters, you'll get near-perfect exposures time after time. This is covered in more detail in Part Four.

So far, we have defined tonality as a record of the scene's brightness values and texture as the subject detail in the scene. Both work together to define the image and fairly describe the palette with which we work. Another key aspect of the black-and-white image is contrast, or the range of shadow and light in a scene.

Contrast

Tonality and texture do not exist in a vacuum; the tones form a visual impression in terms of both their intrinsic value and their

The range in this print can help define tonal categories. The bright white area at the horizon is the spectral highlight, and the whitest area in the foam is the highlight. The sky is a middle gray, and the darkest gray area in which you can see detail is the significant shadow. The curl under the wave that holds no texture is the deep shadow.

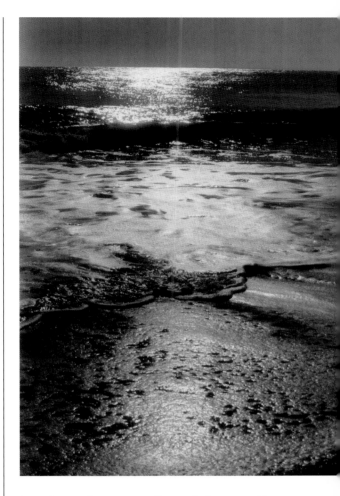

relationship to one another. The context in which they relate is called contrast, which is simply the difference between the light and dark values in the scene. Contrast determines the "look" of the image and has a profound effect on visual effects.

We describe contrast as being high, medium, or low. Photographing at the beach at noon on a cloudless day is a high-contrast condition; an overcast day in the woods is a low-contrast condition; medium contrast might be found on an afternoon hike under a cloud-filled sky. But contrast is determined by more than the ambient lighting conditions. The reflectivity of the subject, the direction of light, and your angle of view (composition) may also create scenes with greater or lesser contrast.

For example, if you are photographing at the beach under the noon sun and the subject is a dark piece of driftwood surrounded by glaring sand, that is generally a high-contrast scene. But it is high contrast only if you want to record detail in the wood, as there is a major difference in the brightness value of the light reflected from the sand and the wood. If you don't care about recording the wood detail (that is, the wood will appear as a silhouette in your print), then the problem with contrast is eliminated, and you may actually be shooting a normal or even low-contrast scene. For photographers, contrast is the difference in light intensity between those subjects that matter—that is, those whose image detail you want to record. Thus, contrast is sub-

ject dependent, regardless of the overall or ambient lighting conditions.

You will generally create greater contrast in a scene, regardless of the subject matter, if you shoot against, or facing, the sun. Called backlighting, this condition places the subject between the camera and the light source. Because the sun is always brighter than any subject that reflects its light, and because a subject that sits within its own shadow is always darker than if it were frontlit, contrast is increased.

Under certain lighting conditions, parts of the scene can be brighter than usual due to the direction of light that hits it and your

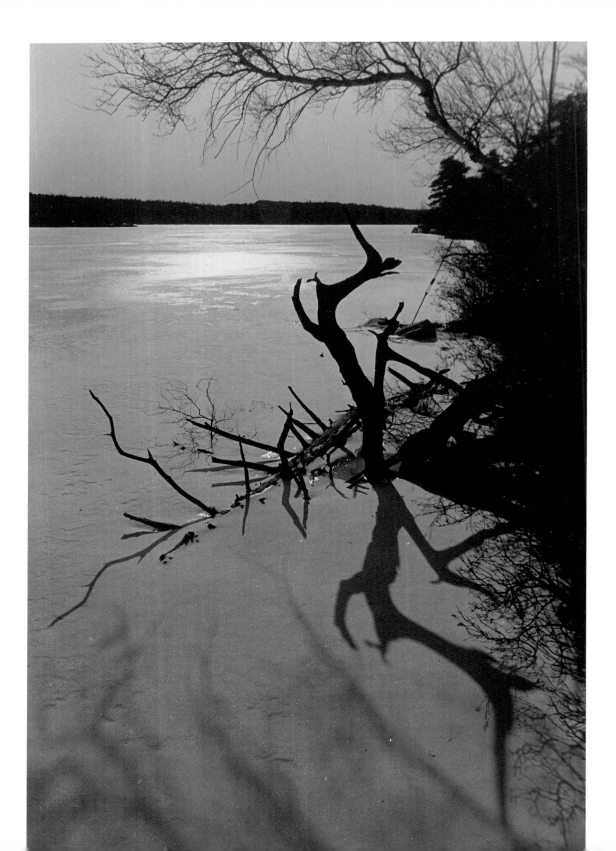

photographic point of view. These light "kickers" can add a flash of interest to your photograph, or they can be a bother. The idea is always to play with the light and to use it to your best advantage; don't let the light create problems that are impossible to solve. If you find that you're struggling against excessively high contrast, try a different angle or composition.

How can you determine the type of contrast in which you are shooting, and how does this affect your technique? You judge the contrast of a scene by taking light readings. An in-camera meter reads the light reflected from the subject, and the values it indicates—the f-stop and shutter speed—are relative measures of the brightness values. Let's say you're photographing a landscape under an afternoon sky. You take readings from the sky, the ground, and any other important elements in the scene and make note of them. (For ease of discussion, we'll lock the shutter speed at 1/125 of a second and use the f-stop as the variable.)

Let's say the clouds in the sky read f/16, the ground reads f/8, and the darker trees read f/4. This is a four-stop range, well within the film's ability to record detail in each tonal area. However, if the sky read f/16 and the ground read f/2, that would be a six-stop range, or a high-contrast condition, which would be a real challenge. Part Four covers the best way to get good results from both conditions. For now, understand that you judge contrast by

The light glinting off this snow-covered lake would ordinarily create problems, but the tree and shoreline serve as a graphic element (a silhouette), so any problem ordinarily caused by such high-contrast conditions is eliminated. We would be hard-pressed to get detail in both the lake surface and the other elements in the scene, given this light and the recording range of the film.

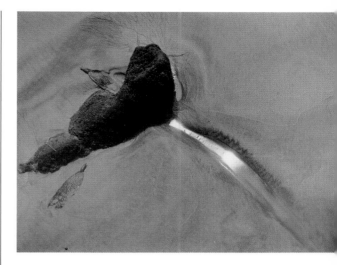

The angle at which this shot was made caught a spectral highlight "kicker" in the rivulet of water in the sand. Move a few inches to either side, and it would be gone. Look for kickers to add visual interest to your photographs, but don't let excessive contrast cause you more problems than it's worth. Here, the light reading was made from the sand (middle gray) rather than from the highlight. If we read from the brighter part of this scene, the sand would be underexposed, resulting in a too-dark print.

making exposure readings from the brightest and darkest parts of the scene in which you want to record image information (a tonal value with details, rather than just a bright or dark tone with no texture and detail), and then expose according to certain easy rules.

Low-contrast scenes, in which the difference between the brightest and darkest parts of the scene is slight, are no problem at all. Again, making light readings and comparing the difference in values will tell the tale. Let's say you're in the desert (a locale that is usually high contrast) on an overcast day. You scan the scene with your meter,

and the needle or LED doesn't move much at all—staying between f/8 and f/5.6. Exposing at either setting (I'd suggest f/5.6, to let in more light) will yield good negatives.

Modern exposure metering systems make easy work of most scenes that have medium- to low-contrast lighting conditions. There is little danger of poor exposure, as the camera meter "reads" the scene for you, and the automatic calculations will place the recorded tones well within the recording range of the film.

On a medium-contrast day, such as during a walk in the hills with billowing clouds

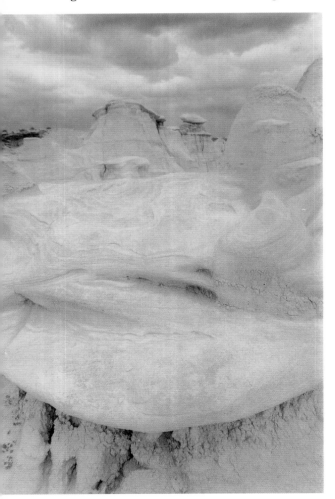

and a blue sky, the readings may vary from f/16 for the clouds to f/5.6 for the brightly lit ground. Again, properly used (a matter covered in Part Four), the camera meter will deliver an exposure that captures all the values in the scene.

As you may now understand, the biggest exposure problem occurs when there is a large difference between the lightest and darkest values in a scene. This doesn't mean that you should avoid high-contrast scenes—indeed, handled correctly, their graphic potential can make for very exciting images—but you should be aware of their pitfalls and how to maximize the light.

Other than for high-contrast conditions, knowledge of how to use the camera or handheld meter will suffice for most exposure problems. Once that technical consideration is put aside, you'll have time to consider more aesthetic matters, such as capturing light and shadow and playing with composition and mood.

Shadow and Light

When photographing outdoors, we are dealing with many types of light. The main light source, of course, is the sun. All else is reflected light or cast shadow. The sky itself is lit by reflection and deflection—the reflection from the earth and the light that

The difference in light values here is slight, as the overcast conditions create a sort of light-diffusion tent over the scene. Even the areas underneath the rock formations have been lit by bounce light coming off other formations. This type of scene poses little exposure problem; it is recommended that after scanning the scene with your meter and determining that a low-contrast condition exists, you expose with the setting that allows in the most light. (For example, if the readings here were f/8 and f/5.6, expose at f/5.6 for best results.) PHOTO BY GRACE SCHAUB

is scattered as it passes through the layers of atmosphere and the particles it contains. Everything we see about us is observed through the energy of reflected light—indeed, that is the first impression we have of the people and objects around us.

Light has a partner that defines form, and that is shadow. Shadow is not the absence of light (which is more a matter of the level of illumination and our ability to see in it) but the momentary stoppage of light by some form and the darkening of an area defined by that form. The depth of that shadow is defined, in turn, by the intensity of light that strikes the form that creates it. Shadows on an overcast day tend to be weaker than those cast under the full sun. The depth of a shadow is also determined by the amount of reflected light around it and the proximity of the shadow-creating form. Shadows have edges and centers and may mimic or extend the shapes that create them.

The contemplation of light and shadow, and how they interact, can affect both aesthetic and technical aspects of photography. Given that shadows define form, you can now begin to appreciate the important role they play in photography and how their rendition affects the mood of the entire scene.

On the beach at Torrey Pines State Reserve in California at low tide, the weathered rocks present a host of fascinating picture possibilities. The sun sits fairly high in the sky, and shadows are minimal. They have dimensionality but without much visual relief. We wait out the day and observe that as the sun lowers toward the horizon, the shadows stretch with it and begin to define new visions. We also see how the texture and grain of the rocks become enhanced as the directional light seems to scratch across their surface. Some shadows are deeper than others, which provides even more visual play, and new forms emerge,

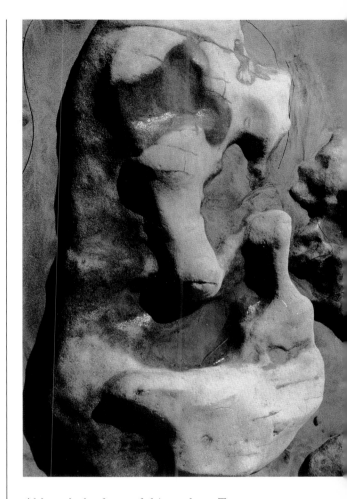

Although the form of this rock on Torrey Pines Beach is fascinating, it is the interplay of shadow and light that gives it true visual interest. As the angle of the sun's rays changes, so do the picture possibilities. Light awakens us to seeing; shadows define and create form.

shaped entirely by the interplay of rock and light. By exhibiting some patience—a key aspect of all natural and outdoor photography—and waiting out the light, we have created an opportunity for more exciting pictures. We have used the shadows to bet-

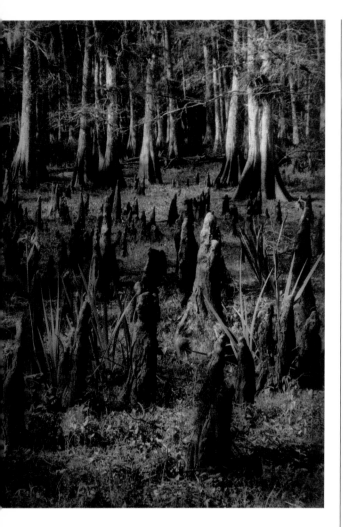

*Early-morning and late-afternoon light offers
perhaps the best shooting conditions, as the
character, intensity, and angle of the light
carry the promise of new ways of seeing.
The direction of light in this late-afternoon
scene in the Florida Everglades creates shad-
ows that further define these forms as well
as creating an aura throughout the entire
scene. When working with light, patience
and early rising have many rewards.*
PHOTO BY GRACE SCHAUB

ter define the forms and cause more of an
interplay of light, texture, and tone.

This is not to say that the best shots are
always made at dusk and dawn—though
some would argue this point. But we have
more opportunity for visually dynamic
images when we pay attention to the play
of light and shadow. This is what often sep-
arates a documentary shot of a place from
a visual interpretation that reveals a sense
of place.

There are some cautions that must be
heeded when working with shadows. If
you've ever used color slide film, you know
that high-contrast conditions can cause
shadows to record as black. And black
shadows do not exist in nature because
there is always some reflected light that
informs them with visual information. (This
attribute of slide film can be used for
graphic effects; in essence, a "fault" is used
to enhance the scene.)

Black-and-white film gives you more lee-
way in the interpretation of shadows. With
slide film, the highlight must be given major
consideration, but black-and-white film can
be exposed with the shadow details in
mind. This is quite a different mind-set and
is key to getting prints in which all the tonal
values that can be recorded are recorded.
Of course, you can always create prints and
images with black shadows, which often
adds graphic punch to your images. The
point is that the choice is yours.

The gradation of the shadow areas, or
darker grays in a scene, is also key. Rather
than "falling off" the edge of gray into deep
black, proper exposure allows us to fully
exploit the nuances in each and every
shadow area we record. Indeed, the beauty
of many black-and-white photographs lies
in the shadow areas; there is a richness of
value in the deeper tones that no other pho-
tographic medium can match.

Seeing Pictures:
A Visual Mind-set

Previsualization

Now that you have all the pieces in place—tonality, texture, contrast, and light and shadow play—you can begin to form an impression of how what you see will be manifest first on film and finally on a print. The process of seeing the results as you take the picture is called "previsualization." Previsualization involves taking in a scene and running it through your mind, deciding what you want to express, and then applying techniques to make it happen. It's dealing with the elements in the scene and considering the light, line, form, and shapes that hold them together—the architecture of the image. You then consider content—the subject, background, and foreground—and decide on the tools and techniques that will create the mood and capture the essence of what stands before you. All this is subject to your interpretation, your consideration of what compels you to make a photograph at that time and place.

When we go outdoors to search for subjects, we are putting ourselves in the hands of an uncertain fate. A cloud-filled sky with azure-blue background can quickly turn overcast; a trek through the woods to photograph a waterfall depicted on a state topographic map may result in finding a trickle over some moss-covered rocks. You never know when your eyes will open to the photographs awaiting you or whether you'll be carrying the camera the entire day without a frame exposed. There's no sense forcing pictures without being inspired, even if you're in the most magnificent setting.

This first occurred to me upon my initial sighting of the Grand Canyon. I had anticipated the trip for years and thought that I'd be spending hours taking photographs and walking the edge of the rim and hiking down into the canyon. The day was fine enough, but my camera sat untouched in my bag. Nothing happened for me. Perhaps it was too big; perhaps it was the tour bus noise. I took a few desultory images, more out of a sense of duty than anything, and tossed them later. When I think back, I realize that there was nothing there that moved me to make images.

That doesn't mean that the Grand Canyon, or any other place you've set your heart on, can't be a source of inspiration. But inspiration comes from a certain mind-set—an openness to possibilities and a preparation for the type of images you might like to make. If I'm going to a new area, I try to do some homework before I set out. I look at topographic maps to become familiar with the terrain and check guidebooks to find the best sites. I am an inveterate map reader and often spend as much time study-

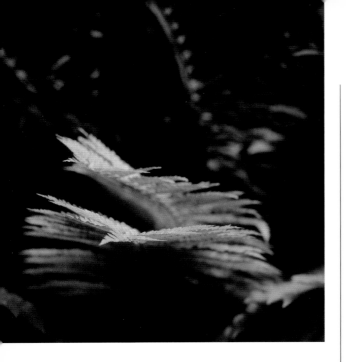

Previsualization is a fancy word for thinking about what your photograph will look like before you take the picture. If you are working with negative film, you actually have two chances to do this—as you're taking the picture, and when you make the print. In the original negative, these fern ends were slightly lighter than the background. Upon looking at the proof sheet, I saw that they looked like birds in flight; when I made the print, I made the background darker to emphasize the lighter forms. In a way, I may have seen this when I took the photograph, but it was only later that the subtext of the image emerged in my mind and on the print.

ing them as I do getting my camera gear ready. I can't spend an endless amount of time in a locale, so information about seasonal changes—and even the best time of day to make certain shots—can be fruitful. Talking with guides, locals, and other photographers can also help.

Serendipity has its rewards, but foreknowledge and a bit of luck is a combination that's hard to beat. Let's say we're heading for Torrey Pines State Park in southern California and want to make still-life shots of the rock forms along the beach. Two important aspects of the place come to mind: First, an early-morning shoot means that the beach will be bathed in shadows, as the cliffs block the sun rising in the east. Second, the rock forms are fully revealed only at low tide; in fact, high tide covers many of the most interesting subjects. Thus, the direction of light and the timing of the tides are key considerations for this locale.

Let's face it—some loss of control and the unpredictability of weather and light are part of the challenge and fun of outdoor photography. If you needed to control everything, you'd stick to studio or indoor work, where every light and shadow can be manipulated at will.

Affinity for a certain environment can also feed your inspiration. You may connect more strongly to the beach, the mountains, or the desert. If you are just beginning to work outdoors, my suggestion is to go to the places you love the most. Your mind-set might be working with the idea that you want to communicate why you feel best in that certain place, and you might be surprised at what you learn. Alternatively, placing yourself in unfamiliar terrain can also stir your imagination. There's nothing like having "fresh eyes" to get your photographic juices flowing.

You may, however, not always have the opportunity to travel where you love to work, yet you want to get going with your photographic studies. Here's an easy exercise you might want to try: A famous photographer once gave her workshop group an assignment before they came to class— to make a series of pictures no more than 30 feet from their front door. Her idea was to break down visual habits—to remove the mundane and to grow accustomed to seeing everyday scenes and subjects in a new light.

As a guest of that workshop, I was fascinated to see the results: soft-focus florals, a path obstructed by a bicycle, a hand reaching into a mailbox, the rush of traffic expressed through the use of a slow shutter speed. The point made was that once you step outdoors, you are leaving the familiar and entering a world of vast potential, limited only by habit and a narrow view.

The true challenge of outdoor photography is to open your eyes to what's around you. The light is how you find it; the subjects are found rather than arranged. What direction you point your feet when you hit the ground, and where you are stopped in your tracks by a potential picture, depends on your mind-set and how you choose to see the world. "Choose" is the operative word here because will is what performs the miracle of creation.

In a purely photographic sense, previsualization in black and white involves understanding how the brightness values in the scene will translate onto film and how you can later mold these tonal values when you make a print. Tones can be shifted according to where the brightness values of the scene are arrayed on the film's recording range by selecting a brightness value as the "foundation" tone—that is, where you place

Knowledge of the best time of day to shoot and of the tide tables made this shot at Torrey Pines State Reserve in California possible. During high tide, all these rock formations are covered with water; in the morning, the west-facing beach is covered in shadow by the towering cliffs behind it. This "face" is like a head from a colossal statue in some ancient ruin—Atlantis, perhaps? Given our limited time, some preparation and understanding of a locale can yield greater photographic possibilities.

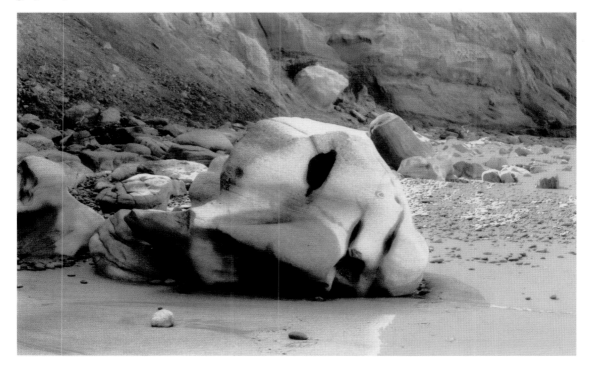

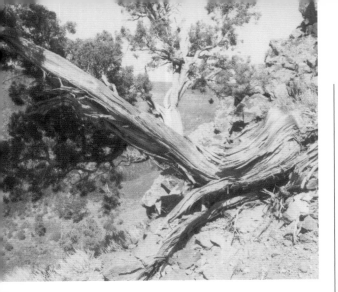

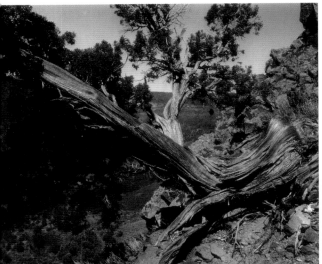

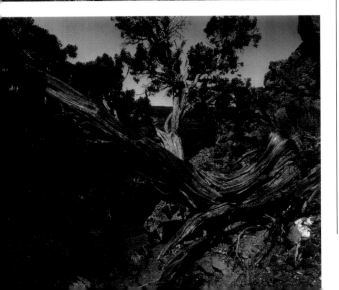

the middle gray when you make your exposure readings.

Let's say you're photographing a fairly high-contrast scene with deep shadows; there's a range of values and bright reflective areas. When you look at the scene, you have a variety of brightness values from which to choose your middle gray. If you read from and use the shadows for your foundation, you'll bring detail into the darkness and probably overexpose the highlight. If you expose for the highlight, the shadows will record as black and the rest of the scene will be subdued. What do you do? That depends on how you want to render the scene on the negative and on which values you place importance in the scene.

Previsualizing tonal rendition takes into account an understanding of the best way to capture the brightness values on film and how they will translate to a print. This scene has fairly high contrast. The first print (top) is an uncorrected version of the negative as exposed. Note that the brighter parts are overexposed, but there is information in the darker, or shadow, areas of the print. This was accomplished by "biasing" exposure toward the shadows (reading the shadow area and closing down two stops). The final print (middle) from this negative shows how print controls handled the highlights and delivered a good rendition in the shadows. Another uncorrected print (bottom) shows what happens on film when exposure is biased toward the highlights or when there is no consideration of the shadow areas in the scene. Delicate shadow areas are lost to darkness, and the print has a harsh, contrasty look. Even detailed darkroom work will fail to bring information into the very underexposed parts of the scene. Thus, previsualization helps us understand how to handle exposure situations in virtually every lighting condition.

You make these decisions by taking exposure readings off the different values. Your meter will translate whatever it reads to a middle gray. Thus, you have a choice of renditions according to how you expose the film. Understanding what happens allows you to previsualize the tonal rendition on film. Thus, you can begin to see what the final image will look like as you take the picture.

There are many nuances to this process, which are covered in depth in Part Four. You can also add touches to the final image when you make a print. For now, consider the creative implications of being able to see what you'll get on film as you go through the initial picture-making process. This eliminates luck and replaces it with skill and the possibility of tremendous photographic rewards.

I was once teaching a class in black-and-white printing, and there was one student whose vision was truly inspired. On the first night of portfolio review, she showed me a set of amazing images, and I looked forward to seeing more as the class progressed through the term. The assignments she delivered, however, were disappointing; the prints were murky, and her eye was being blocked by poor execution. When I spoke to her about this, the reason became apparent—she wasn't taking meter readings and relied on luck and guessing for her exposures. She had developed some odd rationale that the technical side of the process blocked her creative spirit and that exposure guessing was part of the inspirational mix.

It took some time, but I think I finally convinced her that by giving up her manifesto she would actually be freer and that photographic creativity is a matter of both knowledge and inspiration. Once the door of previsualization opened, she began, reluctantly, to see how she could combine the two.

Point of View

Along with tonal considerations comes contemplation of your "take" on the world, or your point of view. That mind-set can take many forms or approaches to photographing subjects and scenes. One is that of a documentary photographer, who sees the picture as a record of a particular time or place. As a document, the photograph takes no particular stance on the subject matter and adds nothing through the use of special exposure or processing techniques. At its worst, the documentary approach is an "I was there" trophy shot, such as the first shot you take after getting out of the car at the rim of the Grand Canyon. With luck and the right lighting conditions, a documentary shot can serve as a wall piece for the home or office. It includes little of the personality of the photographer, other than the fact that he or she happened to have a camera in hand at a certain time and place.

This may seem to be a deprecating description, but we've all made such photographs and will continue to do so. Most of us are victims of the "if it's Tuesday, this must be Belgium" style of travel. Not every picture has to bear the burden of meaning or be the result of lengthy meditation, but the documentary shot is the postcard we make out of reflex and conditioning. It's the shot we're supposed to make (witness the Kodak Picture Place signs in parks) and often do make when moving swiftly through our yearly two-week break.

This approach takes scenes as they present themselves, with no critique or interpretation, and too often relies on tried-and-true composition and framing. A lake in the woods is photographed 50/50, with the symmetry of reflection placidly balanced with that of the real-world scene in the frame. The geyser blows, and we hit the shutter release, along with 500 others, at the instant the steam and water peak.

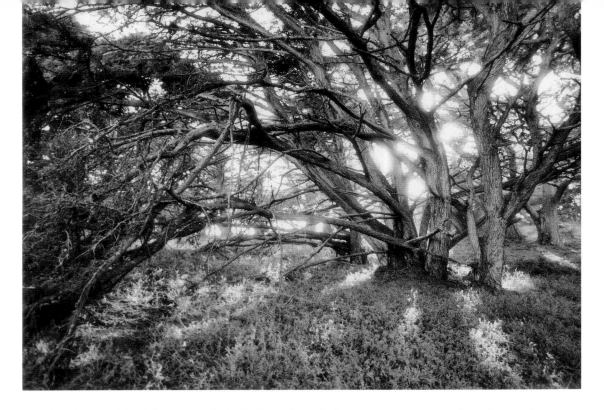

Idealists have a bit of the romantic in their souls and aim to capture scenes that elevate the natural world into a near mystical plane. This image, made in Torrey Pines Preserve in southern California, violates some rules by photographing into the sun. The ethereal is produced here through overexposure, which yields detail in the foreground. The use of a slight diffusion filter over the lens breaks up the otherwise harsh highlights into glowing orbs of light. The tonality, direction of light, and point of view could serve as a subject for a nineteenth-century illuminist painter.

The idealist approach recalls the outdoor school of nineteenth-century academic painting or the pictorialist school of photography that still holds dominion in many photographic circles today. The idealist takes pains to frame the scene to isolate natural elements; the aim is to show us the earth as a Garden of Eden, nature as inviolate, and the scenes they record as the true manifestation of a divine hand in an otherwise despoiled world.

The idealist hikes in from the road's edge to eliminate telephone wires from the framing and trudges through cow pastures to place a barn at its most flattering angle. If beer cans lay rusting in a stream, the idealist either eliminates them from the picture or, if he or she has true grit, carries them out of the woods. To the idealist, nature is pristine, and every technique in the book is used to enhance its charms and build its mystique. Filters, special lenses, and exposure techniques are used to add to the mystery and power of their scenes. If their politics are aligned with their vision, they are staunch conservationists and often use photography as a way to further their cause. Ansel Adams is their saint and Elliot Porter their guardian angel.

Anyone who has spent any time photographing outdoors has to be a bit of an idealist. Our hearts break at the senseless development and the mindless violence that ruin the planet for nothing more than

greed. It is little wonder that we try to capture the beauty of the world around us and idealize the moments we share with nature. Be it nostalgia or an attempt to hold on to a world that our grandchildren may never know, we go out and make photographs that try to express the true power and glory of the natural world.

There are also those who photograph outdoors within a philosophical context, one that considers subjects as covers and ciphers for deeper meaning. The tool often used in this approach is abstraction, which defines a subject's essential qualities without regard for its particular form. Abstraction can also use the subject as a nonrepresentational interpretation of a scene or feeling.

A photographic abstraction begins with the real world and derives its visual form from a transformation of that real subject. That transformation may result in a reference to the whole—as in macrophotography—or may touch other emotions by altering the real in order to create an entirely new visual experience. This sometimes entails abstract expressionism, in which the transformed image brings the viewer into an entirely different realm, one that is oriented toward both the surface and what lies beneath.

Consider the abstraction of close-up work. Here, we take a portion of a subject or scene out of context as a way to appreciate design, texture, or form. Macrophotography also allows us to see in improbable ways. When I was a child, I could amuse myself for hours by sticking my head into a stand of weeds or an unclipped lawn and observing the patterns and designs. I suppose I do the same thing today, but with a macro lens on my camera.

Another way to explore abstraction is to use a small portion of the scene to represent the overall environment. If you hike in dry country, you'll often see miniature formations on the ground that tend to echo the area around you. This may include a rivulet after a rainstorm that, when looked at from above, echoes the entire valley, or a weathered formation that seems to look just like the overall landscape. Because the viewer is not given any scale of reference with which to judge the size of the subject (such as a tree or a person), the smaller subject can represent the whole.

Abstraction also includes what some might call a transcendent vision, that is, a form found in nature that evokes an entirely subjective reaction in the viewer. Minor White and his followers have explored this fully, and a study of his work, as well as that of Walter Chappell and Frederick Sommer, will yield some fascinating images. White studied and professed the philosophy of Carl Jung and others that dealt with matters of archetypes and gestalt, of the internalization of images as key to self-knowledge. Their images were often made with these philosophical stances in mind. Indeed, Edward Steichen's Equivalents—photographs of clouds—were, for him, the purest photographs he made. Rocks and formations become totems, birds, turtles, and primeval forms; ice, clouds, and waves create a wide host of visual possibilities, some of which evoke literal forms while others create ineffable moments that can only be described as visual poetry.

An abstract approach, however, can verge into intellectualism, a way of seeing that may lead to excessive introspection at the expense of communication. People simply may not get it, but that's the price you may have to pay. When you plug into the mysteries that abstraction has to offer, you are opening doors to your inner feelings and perceptions, and you may be surprised at what you find.

The last approach we'll touch upon is that of the realist, an informed eye that draws from both the idealist and the documentary styles of photography. The realis-

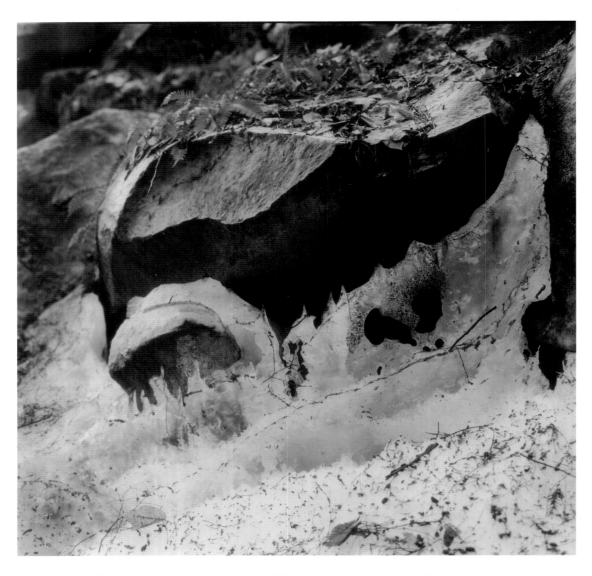

Abstraction offers a real field of play for the black-and-white photographer. Because color has been eliminated from the visual equation, we are able to play with line, form, shadow, and light in new ways. Here, an image of ice and snow on a rock face becomes transformed. The isolation of certain portions of a scene—their removal from the real-world context—can open up a host of possibilities. We can see this image as melting ice on a rock face or free ourselves to create other stories or metaphors in the scene.

tic approach is no more "real" than any other style—all photography being an illusionary image formed by clumps of silver or dye. But the realist opens the frame and includes juxtapositions and subjects that the idealist would reject and, as with the documentary approach, takes things as they come. The difference is that the realist does this with intent, with a thought process that uses the photograph to make a point about the world.

That point may be to show the effects of humans on nature or to bring a narrative sense to the image. Subjects are neither isolated from their context to serve some sense of abstraction nor idealized to create an illusion about a certain time or place. There is little room for nostalgia or sentiment within realists' images, as their concerns are with what they see as the truth of a particular time and place.

While all this sounds quite serious, realists also rely on humor and oddities in their work. The humor may be a bit cynical, but cynicism is often the result of spoiled idealism. Above all, realists want to relate a visual tale that "tells it like they see it."

There is no need for you to enroll in any of these "schools" or to think that there aren't many more approaches you can explore. But taking a stand, one way or another, is a way to begin to see in a certain way. It helps define your vision and calls attention to the fact that you have put some thought into your pictures. It will start the process that leads to a deeper appreciation of what photography can bring to your life and your art.

Tools for Realization

Let's consider some of the tools that can help you realize your vision. We'll start with image content, or what may first attract you. The elements within the scene include the actual subject and the light and shadow that play around it. But you do not see this subject as would a botanist, whose aim

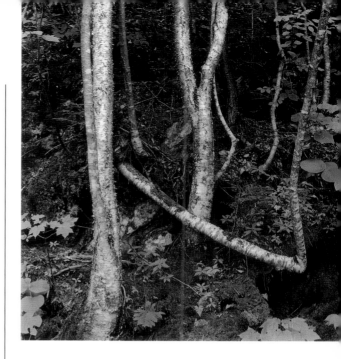

Not every scene need be glamorous or idealized. Though caught in the jumble of undergrowth, the light emanating from these birch trees caught my eye. This, plus the trees' adaptation to tough conditions (note the turn in the toppled trunk as it seeks the light), makes this an image that speaks to the realist's point of view.

might be to record the subject for the study of itself. What you see are the shapes, lines, and forms and how the light plays on the foreground and background.

You then begin to consider how to interpret, or render, the scene before you. You study the subject and its context—the foreground and background of the composition. You choose an angle of view through the use of different focal length lenses—a wide-angle lens, such as a 24mm (on a 35mm camera), gives a broader view, whereas a telephoto lens (150mm and up) yields a narrower frame. You also choose a vertical or horizontal composition.

You walk toward and away from the subject and see how the camera-to-subject distance affects the spatial relationship of the

subjects. A wide-angle lens tends to make a greater separation between foreground and background, whereas a telephoto lens tends to stack, or compress, the subjects within the frame.

You can also choose to isolate or integrate the main subjects through the use of aperture, thus working with depth of field. A wide aperture yields less depth of field and tends to isolate the subject against a tonal pattern, or background. A narrow aperture integrates the subject within the frame, as it tends to make the full picture space sharp.

You can then determine whether you want to change the point of view by tilting the lens up or down. Of course, this also depends on where you're standing and from what vantage point you're taking the picture. If you're working with a wide-angle lens, pointing the lens down will emphasize the foreground and cause the background to recede farther. If you point the wide-angle lens up, you'll be tilting the upper portion of the frame in and causing the foreground to recede. I often use a tilted wide-angle lens to emphasize the clouds out in big-sky country. I shoot vertically and bend back so that as much of the sky as possible is encompassed within the frame.

Composition is what ties all this together. Given the wealth of visual material around us and the considerations of tonality, subject, and meaning, how are we to begin to incorporate this within a frame? Like all modern visual artists, we are subject to the

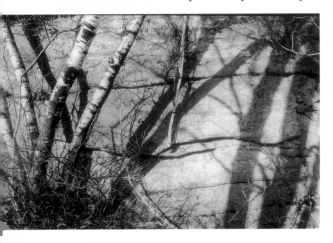

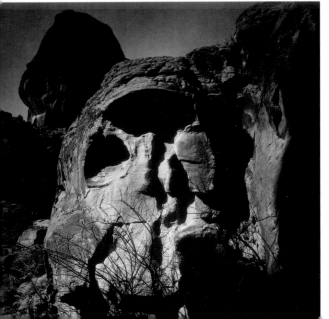

Top: This trail was narrow, so when viewed through a 50mm lens on a 35mm SLR, the framing choice was between the trees on the left and the shadows on the right; neither one was a satisfactory image. By switching to a 24mm wide-angle lens, a wider field of view was encompassed. Carrying more than one focal length, or working with a zoom lens, gives you more options in the field.

Bottom: This awesome rock "face" gazed at me across a steep chasm, one that was easily leaped with the use of a 150mm telephoto lens. Telephoto lenses have a secondary effect—that of "stacking" subjects, or making objects in the background seem closer than they really are. This effect aided the scene, as the boulder in the background now looms even more threateningly than in nature. Drama was added to this image by making a dark print, which highlighted the grim visage in the stone and gave the whole scene a mysterious aura.

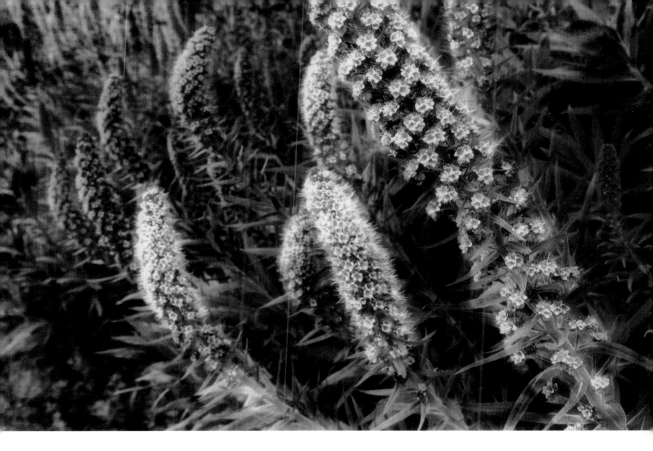

This composition relies on the use of a wide-angle lens to create a foreground-to-background movement (a wide-angle lens makes the difference between foreground and background more pronounced; tilting it into a subject enhances the effect), catching the light on the foreground subject (going from light to dark creates dimensionality), and the use of a shallow depth of field to emphasize the foreground subject. Overall, the balance is created by concentric semicircles, with three rings starting in the middle of the frame and fanning out to the left.

tyranny of the right angle—the viewfinder and the print edges, be they square or rectangular, all end abruptly at right angles. Life is more fluid and less linear than this. We are also held to a two-dimensional expression, one that requires visual tricks to lift itself from that flat plane.

There are some techniques that can help you get your arms around compositional matters. Think of composition as weights and balances, as a way of arranging subjects within a frame so that there is a fulcrum (a center) around which the entire image rests, or revolves. This does not

mean that your main subject should be in the center of the frame—in fact, this is probably the deadliest solution—or that you should split the frame in half and divide your weighting accordingly.

The composition relies more on the weight of tonality and the balance of forms. Dark areas can be counterbalanced or split up by lighter areas or can serve as "negative space" that highlights the subject matter. Subjects that jut out from the corners can be balanced by a receding context that adds dimensionality through sharpness or unsharpness. Indeed, anything that height-

If you want the "big-sky" effect, use a very wide-angle lens (24mm and wider with a 35mm SLR), shoot vertically, and tilt back toward the opposite horizon. The edge distortion of the lens, which can be a problem when shooting architecture, will be used to good effect.

ens dimensionality—be it creative use of depth of field or manipulation of tonal values to make an area lighter than its surroundings—can be employed.

At first you can rely on certain "set pieces" of composition, such as the strength of the triangle, the rule of thirds, the expectation of the semicircle, and the visual excitement of the diagonal line. You can work with vanishing point (a line or reference that leads the viewer's eye through the picture to infinity, where all lines become parallel) or with the repetition of form and design.

If you take some time to look at pictures, paintings, graphic designs, or architecture, you'll see these "generic" compositional tools put into practice. My suggestion is to become conscious of them—to study them, if need be—and then to let them sink in. If you force these tools and impose them on your images, you will get forced results. If, however, you rely on your compositional instincts and take the time to study a subject before you shoot, you should begin to see your own sense of balance emerge naturally in your photography. It's all in there—you almost can't avoid it—but you have to consider these ideas as meaningful before you put them into play.

I often balk at defining what goes into my own compositions because I fear that I'll get stuck in set patterns. But looking over my work through the years, I know that I

Facing page, top: Composition can be thought of as a balance between forms. A balance is created in this scene by the large mass of boulder on a slab of rock being offset by an extended, smaller dark space. The boulder on the left is connected to the small puddle with concentric circles; these circles diffuse the weight through lines of force and tension. The tension is held and resolved by the "pin" of the near-circular form on the right.

Facing page, bottom: This moody shot of the California coast is a good example of the rule of thirds. When working landscapes with sky and ground, this rule suggests that rather than split the scene in two, with half sky and half ground, you should weight the frame so that the ground or sky holds a one-third or two-thirds proportion. This adds more visual interest to the scene. This does not mean that you should sit with a ruler and measure off exact thirds, but look for some visual relief from the deadly half-and-half composition. The thirds are made even clearer here by the break in the cloud edge above the horizon.

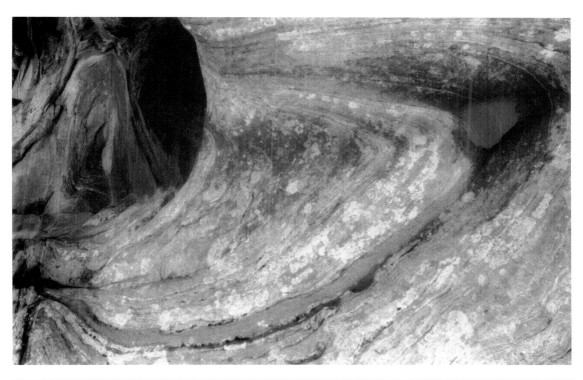

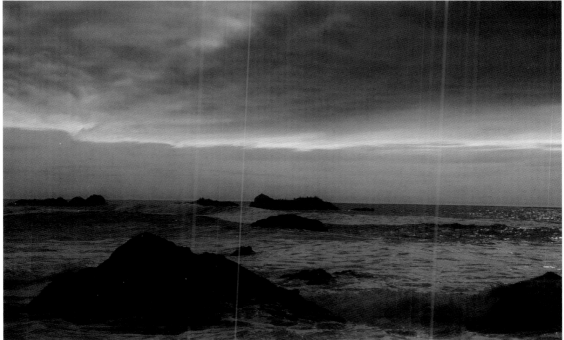

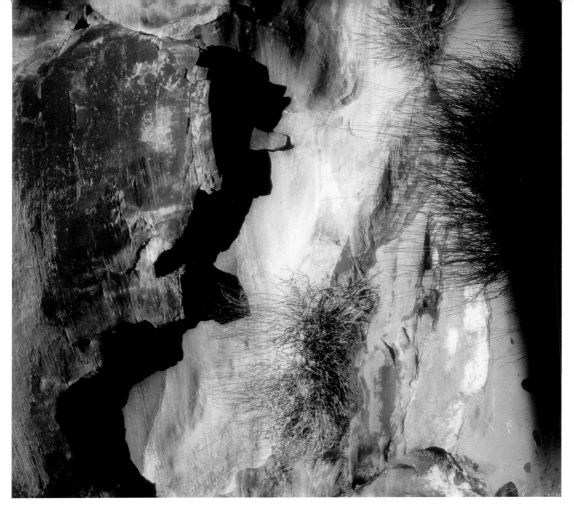

Shapes, forms, shadow, and light—these are the elements that you move around and work with when considering composition. I often shoot on a diagonal or turn images on their side and upside down to exercise my compositional muscles. This scene was originally a horizontal, but after playing with it, I prefer it as a vertical. The form on the left became a face staring across the picture plane. As you enter your images, you may begin to see more than you bargained for when you made the original exposure. This study can then be brought back into the field to help open your eyes to new picture possibilities.

rely on the triangle (straight, reversed, and sideways), the receding line, and the semi-circle. I watch my edges carefully and try to avoid truncation of forms (in other words, I attempt to allow resolution within the frame). If I work horizontally, I watch that my subject is divided by thirds (often with two-thirds holding content, and one-third context or defining shadow); vertically, I

tend to exaggerate height, so I shoot low or tip back my wide-angle lens.

If you're stymied about composition, forget about subject content for a while and shoot for forms—don't even worry about straight horizon lines or logical points of view. I often squint at a subject before photographing it and even look at it sideways and upside down—this way, I remove con-

Nature provides the best study of composition and form. The concentric circles, repeating forms, symmetry, and "basket" of vertical lines make this barrel cactus a miracle of design. The true beauty of it is that the design and the plant's survival come together in one. This is truly where art and life coincide.

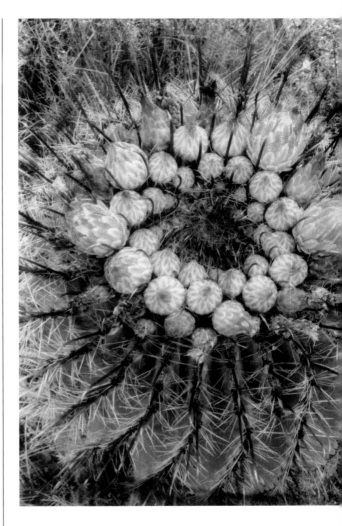

tent and just deal with shapes, the scene balance, and tonal values.

If possible, go to galleries and museums and look at classic and modern paintings. One of my favorite sources of compositional studies is the work of Mondrian, whose boxes and lines are all about balance, weight, and form. Superimpose a Mondrian on a nineteenth-century academic painting and you'll see that composition has not changed that much, despite the content, throughout the years.

The greatest guide you can have for composition is the study of nature itself. Note the delicate symmetry of a leaf or the angles formed by rocks and branches in a rushing stream. See how a flower attracts pollinators and what role light and shadow play in a steep river valley. Watch how clouds form around a mountain peak and how the setting sun defines the horizon. We impose our rectangles and squares on all this to make sense of the rush of energy before us—indeed, that requirement is both our trap and our liberation. Reconciling the two is part of what capturing images from nature is about.

Once you've arrived at your composition—where the frame cuts into the scene, the spatial relationships of the entire scene, and the intimate relationship of subjects within that frame—you then consider how light will record on film. You can decide this when the exposure is made or afterward, when you make prints from the negative. You also determine the mood of the scene through the choice of filters and film stock and how each matches the lighting conditions and the subject at hand.

This may seem like a lot to consider, but that's what's so involving about this craft. As you proceed, keep in mind that these tools and techniques are there to serve you and your vision. As you photograph, you'll begin to integrate these separate issues into the whole and find that many of the decisions become second nature. As you develop your photographic instincts, you'll begin to use them as needed to perform the magic that makes this such a wondrous craft.

Film

This section covers the wide range of films available for black-and-white photography. The discussion includes how film works, film attributes, and how matching a specific film to a subject will enhance the image. Film developing is also covered.

Think of film as a palette from which you can create variations on your images. Once you choose a film and load it in your camera you have begun the process of interpretation. Although the way you expose each frame has a profound effect on results, the recording medium itself is also part of your photographic statement. Aside from a film's speed or sensitivity to light, you can select film based on its unique way of rendering grain, light, and tonality. Each type of film can help you "see" in a different way and can add an expressive touch to your images.

There is a wide variety of black-and-white films to choose from. Your choices include black-and-white negative film (for prints); positive film (for slides); chromogenic film (a black-and-white film that can be processed in color chemistry); and specialty films, such as copy (for high-contrast results), infrared (for special effects), and technical film (for either high-contrast or super fine-grain results). There are also films made specifically for push processing (for shooting in very low light) or that add extra grain to an image.

Although you don't need to understand the intricacies of film technology to make a photograph, an artist who knows the materials of his or her craft and how to apply them will discover a greater freedom of expression. With that in mind, let's briefly explore what makes film work, and how that science can better inform your art.

Film Grain and Speed

All black-and-white film contains grains of silver—called silver halide—suspended in an emulsion coated on the film base. These grains are the light-sensitive material in film and react and change when exposed to light. The area or size of these grains determines how sensitive the film is to light; grains that cover a larger area capture more light and thus are faster, or more light sensitive, than smaller grains.

This relative light sensitivity, or speed of film, is expressed as an ISO number, with higher numbers indicating more light sensitivity and thus a better ability to capture scenes in low light. (ISO stands for International Standards Organization.) Typical film speeds are ISO 100, 200, and 400, with each doubling of the number indicating that the film is twice as fast as, or one stop more sensitive than, the preceding number. The important thing to remember is that when shooting in bright light, a slower film can be

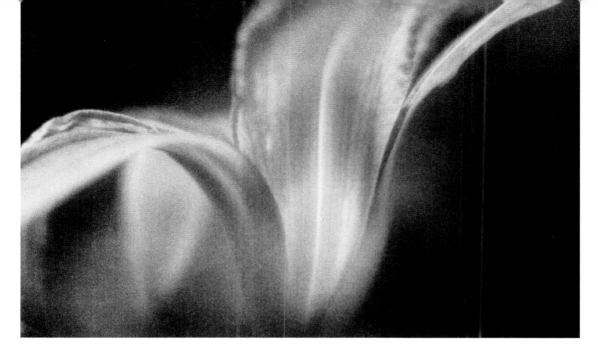

Silver halide grains are the light-sensitive elements in film. When film is exposed to light, these grains react and change in relationship to the intensity of light that strikes them. This image (top) was made with a high-speed film and shows a characteristic grain for that speed. When a section of the image is enlarged (bottom), the salt-and-pepper pattern of the grain structure that forms the continuous tone image is apparent.

used; low-light conditions may require a faster film for hand-held shooting.

Grain is what creates the photographic image. Put exposed and developed film under a high-power microscope and you'll see a salt-and-pepper bunching of crystals. When the millions of grains contained in an image combine, and when they are viewed by the unaided eye, they form the illusion of continuous tones that make up the picture.

Because speed is determined by the size of the grains in the film emulsion, slower-speed films generally deliver finer-grained images when enlarged. This may not make a big difference for snapshot-sized prints, but when big prints are made, the differences become apparent. Thus, the first rule of thumb for film selection is to choose the slowest film speed you can for the shooting conditions at hand. I try to shoot with an ISO 100 film whenever I can, but I always carry ISO 400 for backup.

Coarse grain can add an expressive quality to an image, but it can also obstruct the visual pleasure of the picture. You can go with fine or coarse grain, depending on your taste and how the effect serves the overall impression. Generally, speeds that are close to one another exhibit only slight differences in grain. Modern grain-building technology has yielded fast films with very good grain characteristics.

Image Formation

Just what happens when film is exposed to light? The grains go through a physical reaction that builds what's called density in relation to the amount, or intensity, of light that falls on them. Where more light hits the grains, greater density, or change and growth, takes place. Bright light creates greater density and thus a darker record on the film. Where less light hits, the density is

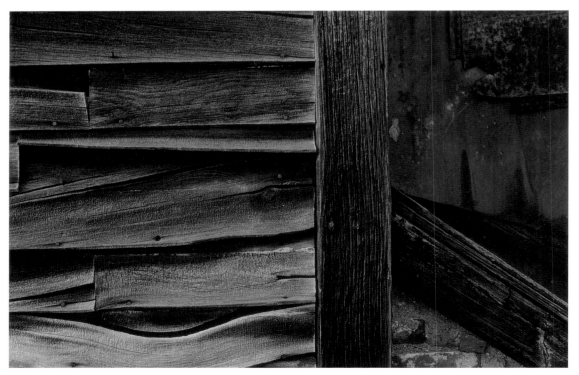

less; thus dark areas in the scene record as light areas on the film negative.

A negative, then, is a record of the light that has struck the film, and it mirrors, in reverse, the various intensities of that light. When a print is made (or when the film is reversed in processing to form a positive), those values are inverted to create a positive record of the scene. This negative-positive process is what makes photography work.

Although the power of light alone creates an image, one more step is necessary after the film has been exposed to be able to see the results. The record of light on film is called a latent image—that is, it's recorded on film but is not yet visible to the eye. By putting the film through a series of chemi-

This negative shows the reverse in tonal values from the print. Note how the light areas on the negative (areas with less density) match the dark areas on the print, and how the light areas on the print (more density) match the dark areas on the negative. In printing, the denser areas (those that received more exposure) resist the light path more than the thinner areas of density (those that received less exposure). This variety of density in the negative is what gives tonal range to the print.

cal baths—a process called developing— the image becomes amplified, and thus visible, and "fixed" so that no further exposure can take place. The way film is developed is also key, as it controls the relationship of greater and lesser density, or the contrast of the film record.

Film Format

Film comes in various formats, or sizes, including 35mm to 120mm roll film and 4×5- to 8×10-inch cut sheet film. The film format you work with is determined by the camera you use. Many of us shoot with 35mm cameras, either SLR (single-lens reflex) or lens-shutter models. Good results can be obtained with 35mm film, even up to fairly big print sizes. Because enlargements are actually magnifications of the image, a medium-format camera using a larger film size—called 120 or 220—usually yields a sharper, more defined, image when big prints are made, assuming that steadiness and lens quality are the same. Fine-art and professional photographers also shoot with so-called large-format cameras that use 4×5-inch and larger film sizes that come in cut sheets rather than rolls.

Your choice of camera depends on your budget, your disposition, and the commitment you have to your craft. This is not to say that you can't get serious with a 35mm camera, but those who become immersed in outdoor photography—particularly landscape work—find themselves naturally attracted to medium-format (120mm and 220mm) and large-format systems. I work mainly with 35mm SLRs when I'm doing "serious" hiking in rough country and medium-format cameras for the rest. Though I've worked with 4×5 cameras in the field, I find that I can get the results I want with smaller formats. This is more a matter of working convenience and my preference for shooting on the move than any prejudice against the large format.

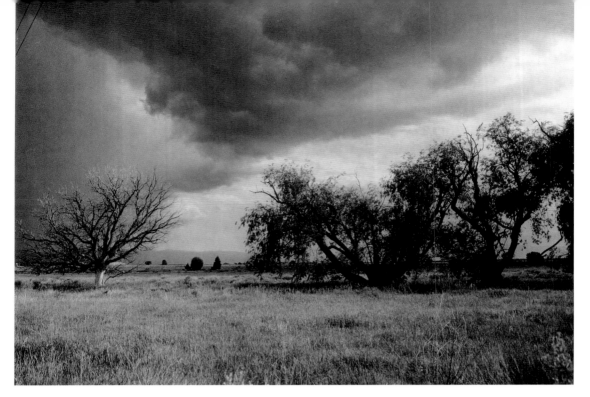

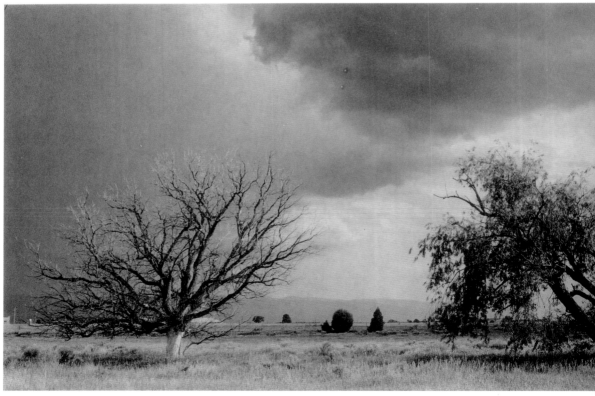

Medium-format images come in a variety of aspect ratios—the relation of height to width of the film frame. The square format is often called 6×6 (measured in centimeters); rectangular formats come in 6×7, 6×9, and, for so-called panoramic images, 6×17. All medium-format cameras use 120 size film; some can handle the longer 220 film. You get ten pictures on a roll from a 6×7 format 120 film, and twenty images on a roll from a 6×7 format 220 film. Some medium-format cameras offer interchangeable backs that allow you to change the film's aspect ratio and to preload film at home for quicker work in the field. Some of these cameras also offer Polaroid backs for exposure and framing tests.

When you work with the square format, you can make square prints or crop the image when prints are made for the more familiar rectangular image framing. If you plan to make rectangular prints from the square image, shoot with that cropping in mind; some photographers use viewing screens in their finders that are already etched with the crop marks to help in this process. If you have never shot with a square format, it may take some getting used to, but with experience, you will have no difficulty seeing the printed framing.

Large-format film comes in cut sheets, which means that each frame is exposed one sheet at a time. You load the film into light-tight holders that slip into the back of the large-format camera. You can also use preloaded film in so-called ready-load packets, which require a special adapter. When you photograph with these cameras, you view the scene on the camera's ground-glass back, then load the film after the composition and exposure settings are made. This necessarily slows down the shooting process, but this pace tends to result in more picture contemplation.

In general, large-format cameras (4×5 is the most common, though 5×7, 8×10, and even 11×14 sizes are available) are used when perspective adjustments are required because you can shift the front and back of the camera to change the relationship of

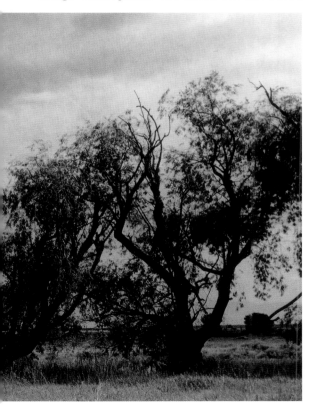

Format defines the aspect ratio (relationship of height to width) of an image, be it negative or print; it also defines the camera used to make the photograph, with terms such as medium or large format. The top print is in a standard rectangular format and could have been printed from a 35mm, 6×7, or 4×5 negative with minimal cropping. To eliminate the wires in the left-hand corner, a print was made in a panoramic format (bottom), which usually refers to an approximate 1:3 aspect ratio. A panoramic camera (such as a Fuji 6×17) could have been used to make this original image in the camera without cropping.

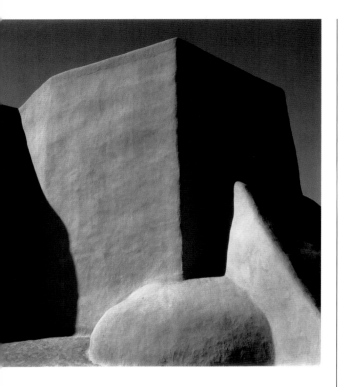

This photograph of the Ranchos de Taos Church (above) was made with a square-format camera, a Hasselblad 503 C/M, on 120mm film. The subject fills the frame to the edges and leaves no room for cropping; thus, I'm locked into a square print. An image of the same church was later made with the same camera, but this time, room was left on the edges so that a rectangular print could be made (facing page). This is not to say that square prints are no good, but framing your subject so that you have an option later is a good idea. Some photographers use etch screens in their square-format cameras viewfinders, which allow them to frame with a rectangular print in mind.

elements or maximize depth of field within the scene. This is most important to architectural photographers, who often deal with keeping lines straight and angles cor-

rectly imaged. The larger negative also yields a much sharper and finer-grained image when enlargements are made.

There are some who argue that landscape and outdoor photography demands the larger format; others find that the more cumbersome operation (compared with smaller formats) gets in their way. The only way you'll know whether it's for you is to try it. Many pro shops rent such equipment. Admittedly, there's a visceral thrill in putting your head under the dark cloth and seeing the full force of the image on the ground glass—it's quite different from peering into a 35mm SLR viewfinder. At one point in your photographic endeavors, give large-format a chance and experience its pains and pleasures for yourself. A few hours of work with the system will convince you one way or the other.

Film Types

The most commonly used black-and-white film is negative film. When exposed and developed, this film yields a negative, or inverted record, of the captured light. The images are made positive when prints are made. So, if prints are your aim, use a negative film.

There is a wide variety of "panchromatic" black-and-white negative films. Panchromatic means that these films are sensitive to all colors of light and will record the luminance (brightness) value of all colors. Some panchromatic film brand names are Kodak Tri-X Pan and T-Max, Ilford HP-5 Plus and Delta, Agfa Agfapan, and Fuji Neopan. These films are available in many speeds, the most common being ISO 100 and 400.

Orthochromatic, or copy black-and-white negative films, are used for making records of documents and line drawings, but they can also be used for in-camera special effects. These films are sensitive to ultraviolet, blue, and green light, but they are not sensitive to red light. When used outdoors, sky can

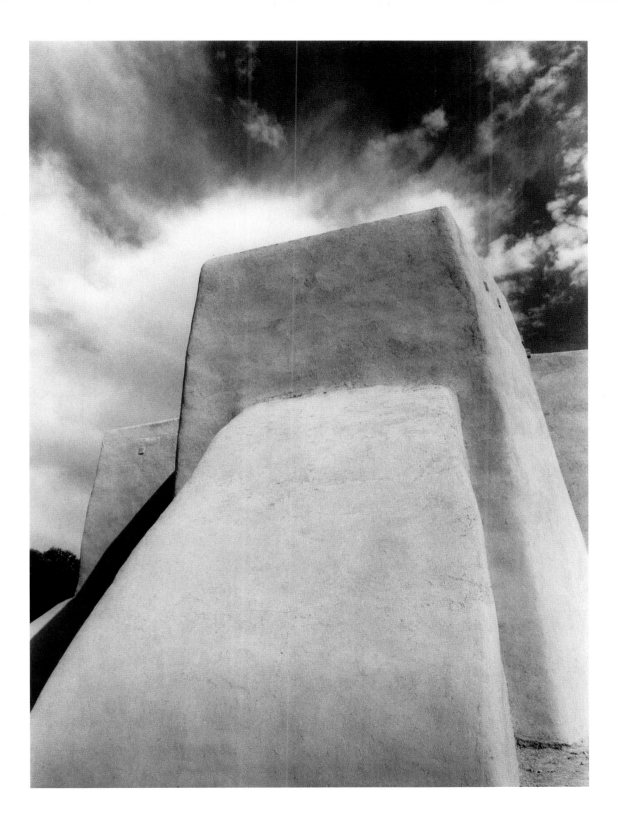

Panchromatic films are sensitive to all colors of visible light and are the most common films used by photographers. They display a full range of tonal values and record brightness values (within a certain range) seen by the human eye. This scene was made on Kodak Tri-X Pan 400 film and shows a full range of bright to dark values.

"block up" through overexposure, making for poor overall landscapes; however, copy films can be used (sparingly) for high-contrast renditions of line and form. (My recommendation is to shoot on panchromatic film and then create a high-contrast rendition, if desired, when prints are made.)

Infrared negative films are also sensitive to all colors but are particularly sensitive to red and infrared (nonvisible) light. Infrared film is used by landscape photographers to make glowing, ethereal images that give an altered sense of reality. A red filter must be used over the lens, as this

blocks most of the light other than the red and infrared record.

There are also high-speed negative films that are intended for low-light photography; their chief use is for surveillance work. Creatively, they can be used to make film images with a grainy, gritty appearance. One such film is Kodak's Recording film (emulsion number 2475), which is still, as of this writing, available in 35mm format.

Another type of fast film is a special breed made for "pushing." All films have a rated speed, a standard that sets their relative sensitivity to light. When shooting conditions demand, this rating can be altered to respond to a need for greater light-gathering power. When you push, you set the ISO dial on your camera or light meter to a higher speed, then add extra time to the developing step of processing.

When you alter the rating in this fashion, the film's sensitivity is referred to as an EI, or exposure index. This does not alter the essential character of the film and tends to gather more light from the brighter parts of the scene (thus increasing contrast). Pushing also tends to increase the graininess of the image. But it's a great aid when shooting with a handheld camera in low light, when an extra stop or two will make a difference. Sports, journalistic, and night photographers often make use of these fast, "pushable" films. In truth, all films can be pushed—this special class allows for very high speed ratings. Two films of this type are Fuji Neopan 1600 and Kodak T-Max P3200. Both can be rated at speeds that range from EI 400 to EI 3200; my tests show that the Kodak film can be rated as high as EI 12,500. You can push-process films yourself or have a black-and-white lab do it for you.

Another versatile film is Kodak's Tech Pan. This film can be used to make high-contrast in-camera originals or to yield extremely fine-grained negatives that can

Films made for copying documents and line drawings can be used in the field to emulate pen-and-ink effects. (This can also be done, to a certain extent, with panchromatic films subject to some darkroom magic.) This image of weeds sticking out of a snowbank was made with AgfaOrtho 25 film, available in 35mm format. The high-contrast original was printed on a high-contrast paper to get the line-drawing effect.

take a very high degree of enlargement, depending on how it is exposed (at certain speed ratings) and developed (the type of developer used). The only drawback is that to get the results you desire, you must go through a fairly rigorous testing phase and develop the film yourself because few labs handle the special processing required.

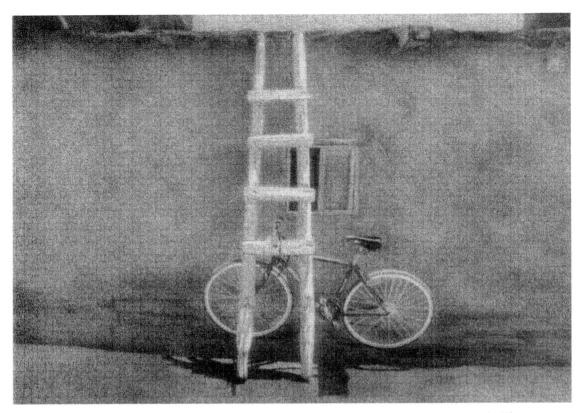

This scene was originally made on Kodak Tri-X Pan 400, then copied onto Kodak 2475 to gain a high-grain effect. Generally, we do all we can to minimize the grainy look in images, but for certain subjects, a grain "screen" can add a pleasing effect. This film can also be used in the field to achieve such effects, but I find that I have more control using it in the studio as a copy medium for prints. ORIGINAL PHOTO BY GRACE SCHAUB

So-called chromogenic films can also be used for black-and-white photography. These films work on the same basis as color print films—that is, during processing, the silver in the film is replaced by dye—but they deliver a negative image that can be used to make excellent black-and-white prints. The chief advantage is that you can have chromogenic film processed in the color chemistry available at minilabs, so you can have it processed virtually anywhere in a little over an hour.

These films—available from Kodak and Ilford—are rated at ISO 400 but can be shot at EI 100, 200, 400, and 800. The lower speeds

deliver finer grain, and the higher speeds increase contrast. (In essence, you are underexposing for higher contrast and overexposing for tighter grain.) Prints from these films made in minilabs usually show a color cast, as they are processed on color paper, but they deliver fine black-and-white images when printed on black-and-white paper.

As mentioned earlier, one of the most intriguing black-and-white negative films is high-speed infrared film, offered by Kodak and Konica (the Konica film is available only in 120 format). Because it records both visible and infrared light, what you see through the viewfinder is not what you'll get on film.

This is a particular favorite of landscape photographers. Grain tends to be high, but the eerie glow the film imparts adds a mystical touch to many scenes. The film must be exposed through a red filter for the best effects and can be loaded and unloaded from the camera only in complete darkness. The film cassette itself should be kept in its light-tight canister before loading and after exposure, until it is opened in a darkroom for processing. You must test for film speed (start at EI 125) and developing times.

Ilford has a similar "special-effects" film, branded SFX 200, which offers an infrared recording capability, though the depth of the effect is not as great as with the Kodak and Konica varieties. This film also should be exposed through a red filter but doesn't require special handling or processing. It is in many respects a very good landscape film, as tones record with vibrancy and an extra touch of glow reminiscent of infrared minus the high grain and the need for custom speed and developing tests.

If you want black-and-white slides for projection, copying, or portfolio reviews (many juried exhibits want slides rather than prints), you have two choices. One is Agfa's Scala, which is rated at ISO 200. This is an excellent film that captures a full tonal scale in both copies and outdoor scenes. The Agfa Scala film is processed by only a few labs in the country, however. You can also shoot Kodak T-Max 100 and have it

When light is low and your film is too slow for the required settings of aperture and shutter speed, you can push the film to get higher effective speed ratings. This is done by overriding the set ISO and shooting at the new speed, then having the lab add developing time to the film. (The entire roll must be shot and developed for this speed.) This scene was made in the deep woods around Lake George, New York. The T-Max 400-speed film was pushed to EI 2400, a plus two and a half stop push; the lab then developed the film accordingly. Note how contrast in lighter areas is increased. PHOTO BY GRACE SCHAUB

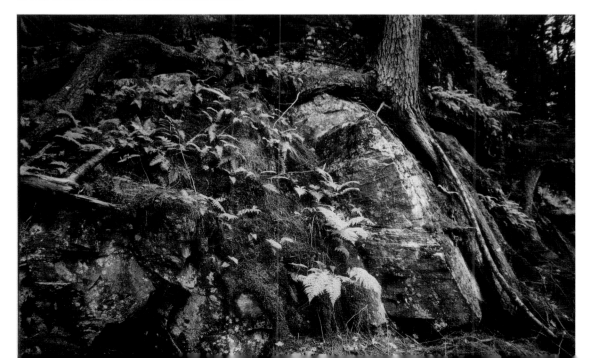

processed as a positive film image. This requires a special processing kit, and not many labs offer the service.

I generally carry a number of different films in my camera bag, though I narrow the selection when I'm working in a specific lighting condition or locale. Here's a sampling of films I currently use (note that film brand names and emulsions may change over time). Unless noted, these films are available in all popular formats.

Agfaortho 25 (ISO 25). Normally used for line copy work, this special-effects film can be used to create in-camera high-contrast images. I use this sparingly, as conventional film can be made to yield similar results in the darkroom or computer printing environment.

Ilford Delta 100 and Kodak T-Max 100 (ISO 100). These are my choices for general outdoor work when I want to have fine-grained enlargements. I suggest carrying a tripod when shooting these films, especially if lighting conditions are unpredictable or you're working with telephoto lenses.

Ilford Delta 400, Kodak Tri-X 400, and Kodak T-Max 400 (ISO 400). These "fast," moderate-grain films are excellent choices for all-around handheld shooting and yield good results in a wide variety of lighting conditions. Although not as fine-grained as their slower-speed counterparts, recent advances in film technology have made them most usable. The Ilford Delta and Kodak T-Max films can be used at EI 800 without any great loss of quality. The Tri-X emulsion is an older technology, but many photographers remain enamored of its lush, silvery grain.

Ilford XP-2 and Kodak CN 400 (ISO 400). These chromogenic films are actually color films that yield a black-and-white image. Their advantage is that they can be processed virtually anywhere in the world in as little as an hour. These are good films in and of themselves but are especially use-ful when you're traveling and need to see results quickly.

Kodak High Speed Infrared (ISO 125). This special-effects film must be exposed with a deep red filter over the lens. It yields glowing images, particularly of sky and plant life, but is not recommended for portraits. It must be loaded and unloaded in complete darkness.

Matching Film to Subject

Given all these choices, how do you pick the right film for the scene and lighting conditions at hand? Although you might want to work with special-effects films for some scenes and certain creative applications, most of your shooting will probably be done with conventional panchromatic films. Here, the choice generally comes down to film speed and how that speed matches up with the lighting conditions and the equipment you are using.

As mentioned earlier, a rule of thumb is to choose the slowest film speed possible for the lighting and shooting conditions. This will give you a negative that has the finest grain and best sharpness and can thus be enlarged (within reason) without fear of image degradation. But there are many times when the light sensitivity of the film may limit your shooting freedom, especially if you work without a tripod and shoot mostly with a handheld camera.

If you're hiking in the woods, you'll encounter many different lighting conditions, from open meadows to deep hollows and glades. Having a film that can handle low light as well as bright conditions is a good idea—a 400-speed film will fill the bill. If you're working at the beach, where the light is bright, a slower-speed film—25-, 50-, or 100-speed film—will do fine.

Let's examine a typical lighting condition and see how film choice affects your shooting freedom. We're hiking in the Great Sand

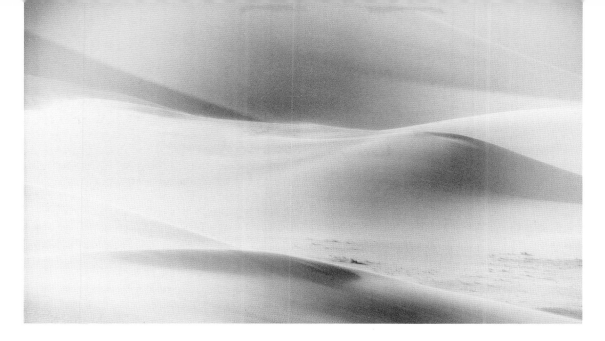

Bright lighting conditions, such as those in the sand dunes in southwestern Colorado, offer little problem when using a medium- or even slow-speed film and telephoto lenses. This shot was made at f/8 at 1/500 second with a Nikon F3 and Vivitar Series 1 70–210mm zoom lens; the camera was loaded with ISO 100 film.

Dunes in southeastern Colorado with ISO 100 film loaded in the camera, and we're shooting with a 70–210mm f/4 lens. (The number following the f/ designates the maximum aperture, the widest lens opening available.) The sun is bright throughout the hike; a typical reading is f/8 at 1/500 of a second. This presents no problem for the equipment or the film being used.

When shooting with a handheld camera, you should be aware of camera steadiness. The possibility of camera shake—which records as a blur—is greatest when you're working with slow shutter speeds or with a long telephoto lens. This motion can result from breathing and the lack of stillness of the body even when standing quietly. Most of us can get shake-free images with "normal" and wide-angle lenses (70mm and wider focal lengths) at 1/30 of a second or faster. Anything slower will probably cause a problem. When working with longer lenses, their heft and lack of centering

around the camera axis increase the possibility of shake at slow speeds.

A rule of thumb to prevent shake is known as the inverse focal length rule, which states that you take the focal length of the lens and invert that number to find the slowest shutter speed that it is safe to use. If, for example, your focal length is 210mm, the recommended shutter speed is 1/250 of a second or faster (1/500, 1/1000, and so forth). If you're working with a 110mm lens, then shoot at 1/125 of a second. When I'm working with a telephoto zoom (such as a 70–210mm), I use the longest focal length (210mm) as my guide. This usually eliminates the shakes from my pictures.

There are other instances when lighting conditions throughout the day, or even on the trail, can vary. Then it's safest to load a faster film (such as ISO 400) to give you more leeway in your exposure settings. An extra stop or two of light sensitivity may not seem critical, but it can make the difference

between being able to catch a shot or not. For example, suppose you take a reading with a 70–210mm lens and ISO 100 film and come up with f/4 at 1/60 of a second. Because f/4 is the maximum aperture on the lens, you can't get any extra light there. The problem is that the shutter speed is too slow to ensure the elimination of camera shake. With a tripod (more on that soon), you could shoot at virtually any shutter speed. But with a handheld camera, the only way out is to use a faster film. With ISO 400 film, you'd have two more stops of light sensitivity available (ISO 100 to 400 equals a two-stop gain); thus the reading could be f/4

at 1/250 of a second (1/60 to 1/250 is a two-stop difference). This would satisfy the minimum requirements for this shot. However, if you wanted a narrower aperture for greater depth of field, you still wouldn't be able to get the shot the way you want without a tripod or other camera-steadying setup.

Therefore, if you are shooting when a fast shutter speed or deep zone of sharpness (greater depth of field) is desired, or when lighting conditions are unpredictable or changeable, use a faster film or carry a tripod. In short, a faster film offers more shooting freedom, especially when you can't predict lighting conditions. You may get a

When hiking in areas where light is changeable, a faster film, such as an ISO 400, allows more leeway. The Everglades in Florida is such a spot, where bright, open meadows alternate with those covered by the forest canopy. This shot was made with Kodak T-Max 400 exposed at f/5.6 at 1/250 second with a Nikon N8008 and Vivitar Series 1, 70–210mm zoom.

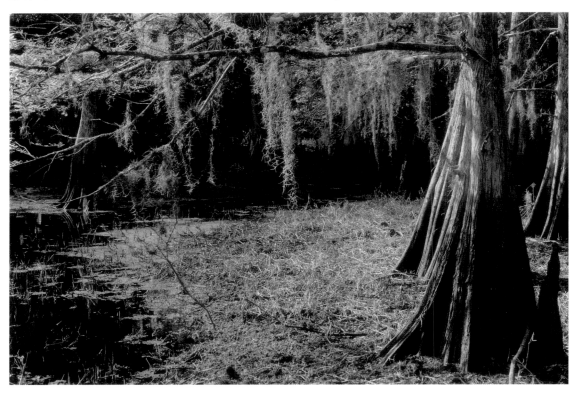

bit more grain in your big prints, but that's a small price to pay for the shooting freedom that faster films afford. But remember, whenever possible, work with slower-speed films.

Tripods and Steadying Devices

A digression on equipment may seem odd here, but one piece of equipment—a tripod—is apropos to a discussion on film selection. If every photograph we make is in bright light with fast film and a fast lens (one with a maximum aperture of f/2.8 or wider), we wouldn't have much need for a tripod. But tripods are essential for work in low light, when shooting with long telephoto lenses, when using slow-speed film, when recording motion effects, and when using certain light-swallowing filters. If you're working with a medium- or large-format camera, there's no question about the need for this device. Tripods come in many makes and designs. The one used for studio work is not necessarily the best choice for outdoor photography.

A tripod is a three-legged platform for your camera. The legs "telescope," so that the tripod can be adjusted to different heights and the legs retracted for ease of carrying. The head of the tripod is where the camera sits; a threaded screw that fits in the receptor on the camera base ensures a tight fit. Tripod heads are as important as the tripod itself. A fixed platform means that you have to position the tripod in line with the subject; a pan and tilt head, therefore, is essential. This works on a swivel that allows you to move the camera to various points on a vertical and horizontal axis. A ball head gives even more facility, as you can move the camera in any direction around a 180-degree base.

Choose a tripod that, when fully extended, fits your height, so you don't have to bend over when taking pictures. Make sure that the legs lock securely and that the camera is steadied even when the legs are fully extended. If you use a lightweight tripod, add to its stability by hanging a weight from the middle of the center post. For outdoor work, where terrain is not always level, use a tripod that allows the legs to be splayed, that is, moved at different angles from the center. Retractable tips in the leg ends, for ground gripping, are also good features.

Portability is key. If you are a "park and shoot" photographer, one who works the roadside more than the trails, weight is less of a factor. But if you do a lot of hiking, you know that every ounce counts, as does the way the tripod collapses so that it's not an encumbrance as you walk. Tripod cases with shoulder straps make carrying easier, as does a strap that attaches the tripod to your backpack.

A key tripod accessory is a cable release, one that allows you to release the shutter without finger pressure. Putting the camera on a tripod and then doing hands-on shooting negates some of the advantages of using a tripod in the first place. With a cable release, you can shoot without unnecessary vibration and ensure steady shots. The cable release screws right into the shutter release button; some cameras require electronic cable releases made specifically for the model and brand of camera.

An alternative to a tripod is, oddly enough, a beanbag. Though certainly not as useful as a tripod, a beanbag can be molded around any solid object, such as a rock or fence post, and used as a base for the camera. Sighting may be difficult in some circumstances, but you'll be surprised what a handy camera-steadier it can be. Photographers who use 35mm and small medium-format cameras can also use a monopod—a one-legged steadying device—in certain instances.

Caring for Film on a Trip

Luckily for us, black-and-white film is not as sensitive to potentially harmful conditions as is color film; this, however, does

not mean that it is impervious to certain environmental and man-made conditions. Heat and humidity wreak havoc with all films, so avoid keeping film in the car during the summer; when traveling, have a cooler dedicated to film storage. Wrap the film in clear plastic bags before placing it inside the cooler to avoid any moisture problems. Conversely, if it's cold outside and you are removing film from a warm environment, allow time for condensation to form on the outer film container, not on the cassette itself.

There was a time when concern about the effects of airport X rays on film was justified. This may still be a problem in certain airports with antiquated equipment, but not so in the United States and most major cities around the world. You must still have very high-speed films (ISO 1000) hand checked, as these fast emulsions will be adversely affected by airport inspection equipment. I stopped having my films hand checked five years ago and have never seen any damage from passing film through the carry-on inspection station; this is true of multiple passes as well. People tell me that the X rays used on checked baggage are stronger, so I always carry my film with me to be safe.

Although film holds on to the latent image for a long time, I recommend that you process film as soon as possible after exposure. The greatest danger is fogging, which can result from various ambient conditions. At the least, fog degrades image contrast; at the worst, it puts a veil over the image. Fog is what causes problems with film that is used after the expiration date on the box.

Finding Your Favorite Film

Kodak, Agfa, Ilford, and Fuji, as well as other manufacturers, make a range of black-and-white films in the ISO 25 to 400 range. Which one is best? The answer can be found through testing—that is, shooting a roll or two of each and making the comparisons yourself. This is not meant to hedge the answer—it's just that film technology is so good these days, and competition so tough, that none of these films can be faulted, and none is vastly superior to another. But there are some differences in grain structure (the way the grains are "built" and thus manifest themselves when enlarged), sharpness, and the overall "feel" of the film. Some are slightly more contrasty than others; some "push" better than their competition. In my experience, these differences are so minor that personal taste is more of a factor than any technical considerations.

My advice is to find one film at each speed that you like and stick with it. That way, you will get to know the film, with all its personality and potential. The same goes for choosing film developers, if you process the film yourself, or use a lab. This consistency removes a number of the variables that can affect the final result, allowing you to concentrate on expression rather than worry about basic technical considerations. Film "behaves" in a certain way, and the ability to predict how it will react will go a long way toward helping you get great pictures.

Film Developing

There are four "wet" steps in the process: the developer, which acts on the latent image to make it visible; the stop bath, which, true to its name, stops the developing process; the fix, which removes unexposed silver halides from the film so that you can hold it in light without further exposing the film; and the wash, which removes chemicals (a wash aid, or a step that makes the fixer more soluble in water, cuts down on wash time). The film is then dried before it is placed in a protective sleeve.

You can develop the film yourself or have it processed by a competent lab. By "competent" I mean a lab that understands the

Developing times and temperatures can have a profound effect on results. These two negatives were created with the same exposure, using different developing times and temperatures. One is a well-balanced negative that will easily yield a good print, and the other is too harsh (contrasty) and will require more work when a print is made. The latter was overdeveloped by two minutes at 4 degrees higher than recommended. Developing film yourself, or working with a lab that delivers consistent results, is key, as this controls an important part of the black-and-white image-creation process.

black-and-white process and, if possible, specializes in that process rather than a drugstore drop-off. Unlike color film, which goes through a highly mechanized process, black-and-white film requires a bit more care, as development is key to getting what you want. Because the volume of black-and-white work is lower, some labs treat it as an afterthought and don't take the care necessary for best results. I suggest that you run test films through a number of labs and choose the one that delivers clean, quality results. Better yet, consider processing the film yourself. This will pay off in the long run.

If you decide to take matters into your own hands and develop your own film, be aware that developing time, temperature, and dilution (or working strength) all affect the final look of the image. Why develop film yourself? This eliminates processing variables and gives you more control over your own work. Luckily, black-and-white film developing is quite simple.

Developing is part of the craft that has important nuances, influenced by the type of developer used, the temperature of the solutions, and the matching of developer with film type and speed. Further study on your part is encouraged, as developing per se is not within the scope of this text. One word of advice is to test different developers (and the time and temperature that yield the best results on specific films) and to stick with one film-developer combination. This will eliminate variables that can have a profound impact on your negatives. Start with the manufacturer's recommendations, and modify your times from there. If you don't develop your film yourself, make sure that the lab you use will work with you to get the best results time after time.

Now that we have some of the basics down, let's explore some black-and-white shooting techniques, including metering, using filters, and ways to get the best results in any type of lighting condition.

Techniques

This chapter covers specific exposure techniques that are key to translating scenes to the black-and-white medium. First is a discussion of metering and exposure, then an examination of filters and their effect on contrast and color rendition. Although many of these tasks can be handled by the automatic exposure (AE) systems in your camera, knowledge about them will help you get the most from every photographic opportunity.

The key to good exposure in black-and-white photography is getting the various levels of brightness in the scene to record properly as various shades of gray, or tonal values on film. Those tonal values can then be used to represent the scene's brightness values on prints.

Because photography is, by definition, writing with light, understanding the vocabulary and grammar of light as it relates to images is part of the discipline and fun of the medium. You are already familiar with the terms highlight, shadow, and contrast. Now let's put them to work.

Light Metering

Put this book down for a while and take a walk with your camera, but don't load any film yet. Before you go, prepare yourself by thinking about the quality of light—about its direction and reflection—and about how the brightness values around you will trans-late to film. Begin to frame pictures through the viewfinder, and notice the collection of lights and darks within the frame. As you go, take selective readings of the different light values. Set the ISO speed at 100, and lock the shutter speed on your camera or meter at 1/60 of a second, and watch the values change in terms of aperture settings. Take notes about how the different areas in the scene cause the meter to respond.

You have begun the first stages of seeing through a "camera eye." You may have noticed that when you pointed the camera at bright parts of the scene, the meter read out narrower aperture values (expressed by higher numbers, such as f/11 and f/16); when you pointed at the darker parts of the scene, the meter responded by reading out wider aperture settings (such as f/2.8 and f/4); and when you pointed the camera or meter at a range of brightness, it read out somewhere in between (such as f/5.6 or f/8).

You measure scene brightness with an exposure meter. This can be built in to the camera as part of a metering system, or it can be a handheld meter that reads out the measurements, which you then manually set on the camera. The meter does not qualify light as bright, dark, low, or contrasty; rather, it translates the quantity, or intensity, of light it reads to aperture and shutter-speed settings. The aperture setting refers

to the size of the opening of the lens, and the shutter speed is an indicator of the duration of the exposure.

The first step of any metering procedure is to program the meter with the speed number (ISO) or light sensitivity of the film in use. This is done automatically with virtually all modern 35mm cameras with DX-code reading pins inside the film chamber (these are a set of three or four gold pins that you see on the left side of the camera when you open the back). With cameras lacking these pins, you must set the ISO number yourself. This light sensitivity is a foundation for the resultant exposure settings.

Every light meter has a metering pattern and an angle of acceptance. The angle of acceptance refers to the "view" the meter takes in for its readings. For in-camera meters, it starts with the viewfinder frame as defined by the lens in use; for handheld meters, each is somewhat different (especially spot meters, which take in a very narrow view), so check your instruction book.

Built-in meters have a metering pattern that defines the area in the viewfinder where it obtains most of its light information. Most built-in meters have a center-weighted pattern; in other words, the center of your viewfinder is where most of the light information is gathered. (Some information is obtained from the edges of the viewfinder frame, but the preponderance of light is read from the center.) The proportion of this weighting differs among camera brands, but a 70:30 (center-to-edge) ratio is usual.

This knowledge is key to obtaining accurate exposures. Think of recording a conversation with someone and pointing the microphone away from where he's sitting. You may pick up some sound, but the recording will not be as good as if you had placed the mike in front of his face. The same goes for light metering; knowing where to point the camera or meter to get the right reading is essential.

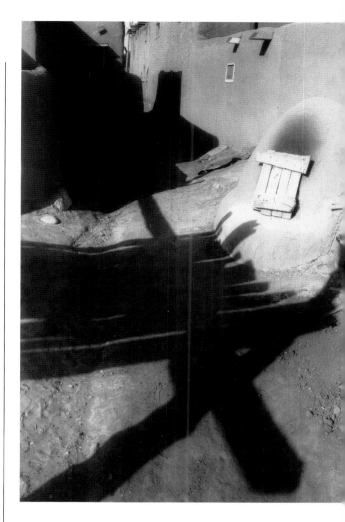

Learn how your meter responds to changing light conditions by taking readings from a scene with a range of brightness values. Point the camera at the different levels of light, and watch how the readouts change. Here, a meter reading off the bright value of the oven door might be f/22, the bright area on the oven itself might read f/16, the adobe wall in sunlight might read f/11, and the deep shadow in the upper-left-hand corner of the frame might read f/4. The metering system is responding to the light levels and giving you settings from each that will result in a middle gray on the film record. The averaging of these values is what results in a tonal balance of light on the film.

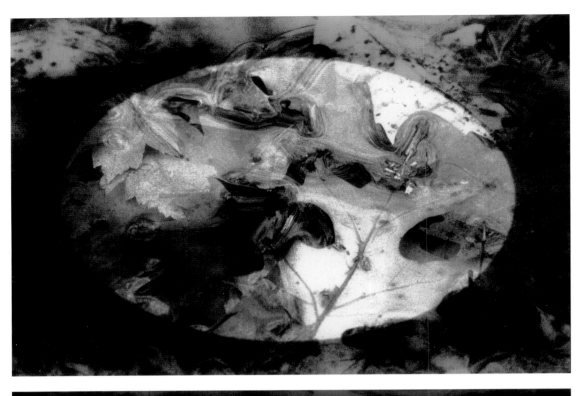

The sun is glinting off a plummeting shaft of water in Zion National Park. The composition includes the waterfall, the base of the cliff, and the surrounding rock formations; the bright water is near the center of the frame and will play a major role in how the metering system reads the scene. If we point the camera at the scene and rely on automatic exposure, we may be in danger of underexposing the areas surrounding the waterfall. Why? Because the bright area is dominant, and the metering system will use it as its basis for the exposure calculations. For a scene such as this, it is better to move the camera off-center, take a reading, lock it using the automatic exposure lock button or set it manually, then recompose and shoot. Although the waterfall will be overexposed on the negative, we can adjust for this when a print is made.

Along the Columbine Trail in the Sangre de Cristo Mountains near Red River, New Mexico, there's a bright sky behind a stand of pines on a ridge. We point the camera at the scene and make a picture based on the camera readings. The negative comes back with the sky well exposed but the ground underexposed. We could have prevented this by including more of the ground area in the viewfinder, taking a reading, and then recomposing to the original scene.

The chief cause of exposure problems is simply not knowing where to point the camera to take the proper reading. Here are a couple of tips:

1. *Understand how your camera or light meter reads light.* Is it center-weighted? Do you have a spot meter option? Does it use internal software to calculate various exposure scenarios? Knowing where information is gathered is the key to proper exposure reading procedures.

2. *Think of the meter as a microphone, and point it at the subject you wish to record.* This might mean moving the camera from your original composition to take a reading and then recomposing after the exposure is locked. Most automatic exposure systems have an AE lock button; this allows you to hold exposures while staying in automatic, even if the light coming through the viewfinder changes when you recompose. In some cases, the AE lock is built in to the shutter release button. Holding the shutter release halfway down activates the lock. If you don't have an AE lock button, shoot in manual exposure mode and set the readings yourself; these will not change when you recompose.

There are four main types of lighting conditions that cause problems with in-camera, reflective-type metering systems: (1) backlighting, where the light behind the main subject is considerably brighter than the subject itself; (2) a preponderance of very dark areas; (3) a preponderance of very bright areas; and (4) scenes with very high contrast.

When you have backlighting, failure to read for the subject usually results in subject underexposure. The meter is not subject selective unless you do something to

The metering pattern of your camera tells you where in the viewfinder frame the camera gets its light information. Most cameras with built-in meters have a center-weighted averaging system. Center-weighted means that the preponderance of light is read from the center of the viewfinder frame; averaging means that the system averages the various brightness values detected. The top image depicts how the center-weighted system "sees" the light in a scene. Although it takes some of the edge light into consideration, the main area is dead center, with the sensitivity sloping off from it. The bottom image is the same scene as detected by a spot-meter pattern. The spot system reads a very small portion of the viewfinder frame and is used for discrete readings from a scene.

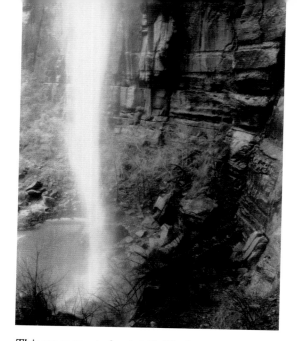
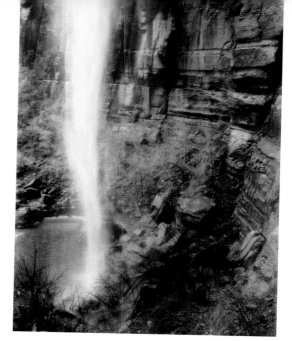

This uncorrected print (left) shows the best solution to the exposure problem. To avoid underexposure—and thus loss of image information—of the rock formations, take readings from the area away from the bright water, lock in the exposure, recompose, and shoot. The brighter areas of the scene can be corrected later when a print is made; in the final print (right), the bright and dark areas have been brought into balance with printing controls.

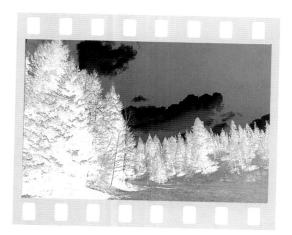
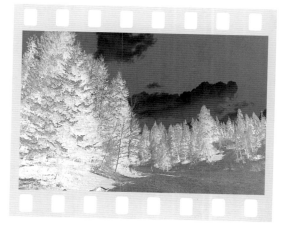

This set of negatives shows a classic failing of landscape photography—a well-exposed sky and an underexposed ground. This comes from allowing the bright sky to play a dominant role in the exposure calculations. The first negative shows a typical result, with the sky well exposed and a loss of image information in the ground. The second shows a better result, obtained by placing more of the ground in the viewfinder frame (but keeping some sky present), locking the exposure, recomposing, and shooting. Note how more information has recorded in the trees. The slight overexposure of the sky can be corrected later when a print is made.

60

Potential Problem	What to Look For	Solution
Backlighting	Light behind the main subject is considerably brighter than the main subject; shadows fall toward you; when you squint, the subject appears as a silhouette	Meter from the main subject, or include more of the main subject within the viewfinder when metering, then recompose and shoot
Dark dominance	The main subject is quite dark, and you want to retain its value on film, as in a moody forest scene or a deeply overcast sky	Meter from the dark area in which you want detail, and close the lens down or increase shutter speed by one to two stops (in manual exposure mode or with the AE compensation dial)
Bright dominance	An overall bright scene, such as sunlit snow or a white-sided church in sunlight	Meter from the bright area, and open the lens up or decrease shutter speed by two stops
Very high contrast	The difference between light and dark brightness values is four stops or more	Meter from the shadow area, decrease the exposure two stops, and decrease developing times 20 percent

make it so, such as take a close reading of the subject or compensate the exposure to make up for the very bright light behind it.

When large dark or light areas dominate the picture space (such as a deep shadow or a bank of snow), the metering system tries to compensate to either lighten or darken the scene, respectively. Awareness of this allows you to compensate for a better exposure.

Once you understand how your in-camera meter works, you usually can rely on it for accurate exposure readings that deliver quality images. Modern cameras and their microchip innards offer multiple metering modes, metering patterns, and light-calculating programs that handle virtually every exposure task. If you have a camera that lacks a meter or want to expand your metering capabilities beyond what your model offers, you might want to consider a handheld meter.

There are two types of handheld meters: incident and reflected. The incident meter measures light falling on the subject. It is concerned primarily with the ambient light in which the subject sits. Its advantage is that it ignores reflections from the subject and backlighting that might otherwise throw off the calculations. You use an incident meter by reading from the subject (or in similar light) back toward the camera position.

The reflected-light meter (which is also the type found in cameras) measures light

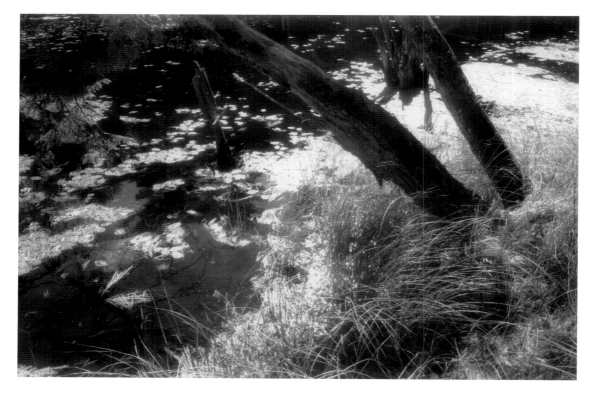

This is a classic backlit scene, in which a bright area in the center of the frame (the light reflecting off the leaves in the pond) can throw off exposure readings. This uncorrected print shows how taking a reading off an area away from the center (from the grass on the lake bank) adds exposure so that some detail records in the bank and the overhanging trees. The bright areas can be dealt with later when a print is made.

reflected from the subject. The main type of handheld reflected-light meter is the spot meter, which deals with discrete portions of the overall scene. The spot meter is pointed directly at the subject from the camera position.

Meters average light readings and yield settings that cause the average to be the middle gray on the black-to-white recording scale. The spot meter yields a reading from a discrete brightness value that, when translated to aperture and shutter speed, results in that value being recorded as middle gray as well. As you'll see, understand-

ing how meters work will open the door to tremendous creativity in black-and-white photography.

Translating Light to Tonality

To better understand the implication of middle-gray averaging and how this affects the way light in a scene is translated to tones in a film and a print, let's step back a bit and explore some basic concepts of exposure. Exposure is a balance between the light in the scene, or the scene brightness, and the film's ability to properly record that light. (The scene brightess is the average of the

brightness values in the scene, as calculated by the camera's built-in meter or a hand-held meter. The average of brightness values is sometimes called an exposure value, or EV.) The fulcrum between the scene brightness and the film's sensitivity, or speed, is created by the light controls in the photographic system—the aperture and the shutter speed. Think in terms of a balanced seesaw, where the weight on one end needs to be counterbalanced by the weight on the other.

As mentioned earlier, when a meter calculates exposure, the brightness values are averaged to deliver a middle gray on the film's recording scale. The aperture and shutter speeds that create that tonal value on film are dependent on the brightness values in the scene as well as on the film's speed. Thus, given the same scene, a film with a speed of ISO 400 will yield the same balance of tones as ISO 100 film with aperture and shutter speed values that are two stops faster.

Let's say we're photographing along the Housatonic River in New England on a sunny day with ISO 100 film loaded. We lock the shutter speed at 1/125 of a second and point the camera (meter) at the scene. The blue sky reads f/8, the ground and trees f/5.6, the clouds f/16, and the dark area along the river f/4. Assuming that there's a fairly even distribution of these brightness values, the meter evaluates the light and averages to f/8. (Of course, the distribution of values is usually not even.)

What does this f/8 reading result in? If f/8 is the middle-gray tone, then that part of the scene that reads f/16 is two stops brighter (thus denser on the negative), and that part of the scene that reads f/4 is two stops darker. Thus, when exposed at f/8, the brighter areas record with more density and the darker areas with less. The various brightness values in the scene are thus placed correctly on the recording

When the camera "sees" this scene, it takes in all the brightness values and averages them to get the exposure reading. Here, the average of f/16 (bright areas and clouds), f/8 (blue sky), ground and trees (f/5.6), and dark areas in the river's bank and surface (f/4) equals f/8. Given that you've locked your shutter speed at 1/125 second (which means that the aperture will vary when brightness values change), that will be your final exposure.

range of the film and are read as lighter and darker tones that correspond to the brightness values in the scene. All is well because this range is well within the film's ability to record.

But let's say we restrict the reading, and thus the resultant exposure, to just one brightness value—the clouds, or the brighter f/16 value. As mentioned, the photographic exposure system is built around the assumption that the resultant reading will yield a middle-gray placement on the recording range, whether it results from an averaging of a range of values or from one

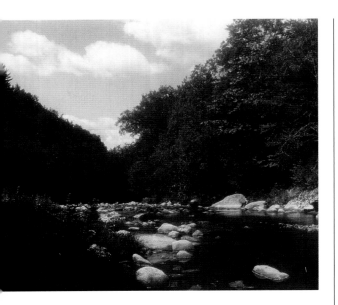

By taking a reading off the sky, we have translated the brighter values to middle gray (darker) values on the film. This results in a fine exposure of the sky but loss of most of the image detail in the rest of the scene through underexposure. All the values on the film work in lockstep, so if you expose a bright area so that it records as a darker area on film, every other dark area will become even darker. This uncorrected print shows the dreary results.

value alone. If the clouds (the bright areas in the scene) are placed as middle gray on the film, all the other values work in "lockstep," and the f/8 reading (the sky) will become darker, and the rocks (f/4) will become darker still. What we have done by not reading the scene properly is to throw off the meter's ability to do its job, thus creating an underexposed image. Many areas in the scene will not show any detail, or image information, and will look almost blank on the film negative.

Let's now restrict the reading to the dark area of the scene—the river surface and left

foreground (f/4.) If we place the darkest value in the scene at middle gray, the brighter parts will be overexposed. The bright areas (highlights) will "burn up," lose image information, and look harsh in the negative and print. The clouds will become harsh white splotches in the sky. This will result in a negative that is difficult to print.

What happens if instead of ISO 100 we load 400-speed film in the camera? Because the film is two stops more sensitive to light, all our values shift correspondingly. That which read at f/5.6 now reads at f/11; that which read at f/16 reads at f/32. What does not change is the placement of the averaged value at middle gray. That's because in

If we expose only for the darker parts of the scene, detail will be recorded in the shadows, but the brighter areas will be overexposed. This uncorrected print shows the results. The key is to average values, or to read the shadow areas and close down two stops. Here, if we read the darker areas and got f/4, a two-stop shift would give us f/8, the right reading for this scene.

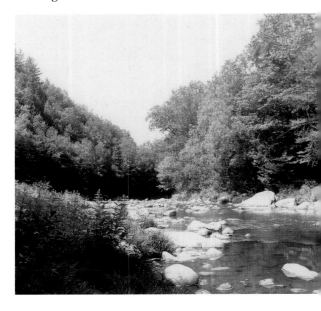

the exposure equation, the scene brightness, or exposure value, does not change. What we have changed is the film speed; thus the aperture and shutter speed change to accommodate the higher light sensitivity of the film. The way the tones spread on the ISO 100 and 400 film will be the same.

This speaks to the notion of equivalent exposure and how we can manipulate aperture and shutter speed to "solve" the same exposure. In any given scene, with a certain film loaded in the camera, we have two fixed values on opposite sides of the seesaw. The balance between the two, or the light-controlling part of the photographic system, is the aperture and shutter speed. Thus, if we have an exposure of f/8 at 1/125 of a second and want to increase the shutter speed to 1/500 second (and still have the same overall exposure), we have to "spend" two stops of aperture. This results in an aperture of f/4.

By altering the light sensitivity of the film in the camera—exchanging ISO 100 for ISO 400 film—we have given ourselves two more stops of light value with which to play. We can use that extra light-gathering power to increase the shutter speed or stop down the lens more. In addition, we can balance aperture and shutter speed to arrive at different solutions to exposures, thus attaining different image effects. The accompanying chart shows the possible variations within one scene with ISO 100 film versus ISO 400 film. All these settings will result in the same exposure on the film.

ISO 100	ISO 400
f/16 @ 1/30 second	f/16 @ 1/125 second
f/11 @ 1/60 second	f/11 @ 1/250 second
f/8 @ 1/125 second	f/8 @ 1/500 second
f/5.6 @ 1/250 second	f/5.6 @ 1/1000 second
f/4 @ 1/500 second	f/4 @ 1/2000 second

Aperture and Shutter Speed Manipulation

Along with light control, aperture and shutter speed have a profound effect on how the scene will record. Aperture controls depth of field, or the zone of sharpness within the picture space, and shutter speed determines how motion records on film. In most cases, aperture is the key to outdoor photography. Shutter speed becomes important when camera steadiness is a concern (see Part Three) and when we want to either freeze fast-moving subjects (with a fast shutter speed, such as 1/500 or 1/2000 of a second) or show motion as a flow (with a slow shutter speed, such as 1/4 or 1/2 of a second.)

Aperture settings are a key value in outdoor work because the opening in the lens determines the depth of field. Depth of field is, simply put, the way we give the effect of dimensionality in a two-dimensional plane and show subjects as in or out of focus that are at distances different from the focusing distance set on the lens. In photography, sharpness is partially the result of how light forms on film, and points of light are sharper than blobs of light. When we focus on a scene, we are focusing on only one plane at a distance from the camera to the subject; the light from that distance forms points on the film, and light from other distances forms blobs, or circles of lesser and greater diameter. The more out of focus the subject, the greater the diameter of the circle of light.

As we narrow the aperture (from f/5.6 to f/8 to f/11, and so forth), we constrict the angle of the rays of light passing through the lens, causing rays of light reflecting from subjects to converge closer to the film plane and thus form smaller circles (these are called circles of confusion). Light records that converge to form points of light rather than blobs appear sharper to the eye. Luckily, we have a toleration of

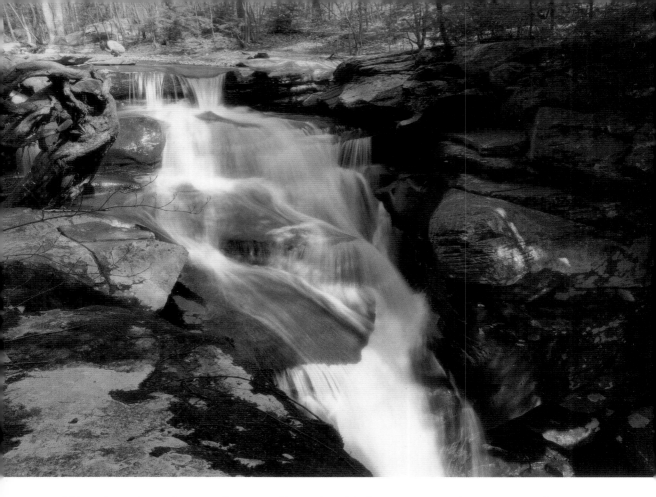

Although outdoor photography generally works with the aperture as the main consideration (because of issues of depth of field), shutter-speed controls can sometimes play a dominant role. Here, to record the flow in a fanciful way, this waterfall in upstate New York was exposed at f/22 at 1/8 second. To ensure steadiness, the camera was placed on a tripod.

unsharpness and see as sharp those circles smaller than a certain diameter.

The depth of field, or zone of sharpness, is determined by three factors: the distance from the camera to the subject, the focal length of the lens, and the aperture of the lens when the exposure is made. The rules of thumb for how these factors affect depth of field are as follows:

1. The farther away the camera is from the subject, the greater the potential depth of field, given the same focal length and aperture setting.

2. The wider the angle of the lens (the lower the focal length number), the greater potential depth of field at any camera-to-subject distance and aperture.

3. The narrower the aperture, the greater the potential depth of field with any given focal length and camera-to-subject distance.

The converse of all these is true as well.

Let's say you're on a rim trail along the Rio Grande gorge in northern New Mexico. The camera is loaded with ISO 400 film. The trail is right along the valley wall. You come across a gnarled juniper on the trailside and

want to ensure that both the tree and the valley sweeping out below are sharp. Here, your choice would be the widest possible focal length (perhaps 24mm) at the narrowest possible aperture (f/16 or f/22). Given that you are limited to how far back you can stand (remember the valley wall), these two factors will give you the best possible chance of achieving the greatest depth of field and thus sharpness in both the foreground and the background.

You follow the trail and come across a sage bush with a fascinating pattern in its branches. You want to isolate the branches and the silvery leaves from the background, which is quite busy. Here, you might choose a telephoto lens (150mm) at a fairly wide-open aperture (f/4 or f/5.6). This will eliminate any possible sharpness in the areas behind the bush, thus creating dimensionality for your main subject.

The ability to juggle aperture and shutter speed—using the notion of equivalent exposure—is what allows us to shoot under essentially the same lighting conditions (EV) yet change the aperture values.

Let's say that we take a reading from the first scene—the tree on the trail edge—and come up with f/8 at 1/125 of a second. These are the values that will deliver a good exposure of the scene. Each step in shutter speed and each change in aperture diame-

ter is equal to one stop of light. In the shutter speed sequence of 1/30, 1/60, 1/125, 1/250, the amount of light coming through the lens is halved with each step. If we went from a faster shutter speed to a slower one, we'd be doubling the amount of light with each step. In the aperture sequence f/2.8, f/4, f/5.6, f/8, f/11, f/16, the aperture is narrowing, allowing half the light through the lens with each step. Reverse the sequence and you'd be doubling the amount of light with each step. As you can see, we are dealing with halving and doubling of each light-controlling variable.

Aperture settings are critical for getting subjects sharp throughout the picture. This cholla cactus and its cousin stood about twelve feet apart in Joshua Tree National Monument. The depth of field was being stretched to the limit here, as I was very close to the foreground cholla. To get the background cactus to be recognizable, I used a 20mm lens set at f/22. To get the greatest potential depth of field, use the widest angle lens possible at the narrowest aperture possible under the lighting conditions.

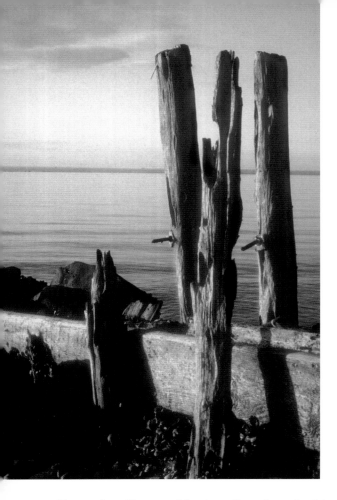

To get the pilings and horizon line sharp in this scene (left), I used a 50mm lens set at f/16. Because the light was low, I used a fast film (ISO 400 pushed to EI 800) but still had to use a tripod because the resultant shutter speed was 1/15 second.

Depth of field can also be used to make the background unsharp. This can add dimensionality to a scene, as the visual contrast between sharpness and unsharpness makes the sharp area stand out much more. For this shot (right), I used a 100mm macro (close-up) lens focused on the blade of grass. Exposure was 1/500 second (for camera steadiness) at f/2.8 with an ISO 100 film. The maximum aperture on the lens was f/2.8; thus, I saw this scene in the viewfinder as it recorded.

Back on the trail, remember that the camera has given a reading of f/8 at 1/125 of a second. We want to maximize depth of field, so we want to shoot at the narrowest aperture on the lens, which for our 24mm is f/22. We shift the aperture setting to f/22 (a three-stop change), and the automatic exposure system balances the shift by reading out a shutter speed of 1/15 of a second.

Both settings—f/8 at 1/125 of a second and f/22 at 1/15 of a second—allow in the same amount of light. The exposures are equivalent, but the second exposure maximizes the depth of field.

Remember, the meter doesn't make subject evaluations—it doesn't know how you want to render the scene. But it does gives you a reading of how the light translates to

aperture and shutter-speed settings. It is up to you to shift those readings, using equivalent exposures, to get what you want. You can shift them in automatic by changing one of the variables—aperture or shutter speed—and the system will make a corresponding shift in the other value for you. Or you can shift them in manual exposure

When doing close-up work, depth of field is critical, as you can have a zone of sharpness as narrow as an inch. For this close-up (right) of an orchid, I used a 100mm macro lens at f/22; the tripod-mounted camera exposed the scene at 1/8 second.

When shooting long distances, aperture settings are less critical, as infinity is considered the distance that is greater than the last distance indication on the lens barrel. This allows you to use a telephoto lens at the fastest shutter speed possible, thus ensuring hand-held camera steadiness. This shot of a cloud-shrouded range of mountains near Durango, Colorado (below), was made with a 70–210mm lens at the 210mm setting at f/5.6 at 1/500 second.

When the camera "reads" the bright-white wall of this church in Newfane, Vermont, it responds by translating that brightness value to middle gray, thus resulting in a gray rather than a true film record. To get the correct tonal values recorded on film (which makes it easier when prints are made), keep an eye out for such scenes, and remember to compensate exposure accordingly. Here, the exposure was made at plus two stops from the camera reading. This moved the bright-white value to its correct place on the film's recording range. Thus, the original reading was f/16 at 1/250 second; the compensated reading was f/8 at 1/250 second (it also could have been f/16 at 1/60 second).

mode, always remembering that you have to make the rebalancing setting yourself.

Let's now prioritize shutter speed. We come across the Rio Pueblo as it rushes down to the Rio Grande. Because we want to record the flow of the river as a continuous sheet of water, we set the camera on a tripod to ensure camera steadiness at the slow shutter speed required for this effect. Let's say the exposure system reads out f/5.6 at 1/125 of a second, and we want to expose at 1/8 of a second to create the desired effect. Thus we have to change the shutter speed by four stops. In automatic, the camera does the work for us and shifts the aperture by a corresponding four stops to f/22.

Knowing how to juggle aperture and shutter speed is one of the keys to expressive images. If you understand their relationship and how film speed, aperture, and shutter speed can be manipulated to give the proper exposure and render the scene in

the way you desire, you'll have mastered an essential creative aspect of picture taking.

Tonal Manipulation

The way you render tones, or translate brightness values in the scene to film, is independent of depth of field or how shutter speed interprets motion. The rendering of tones has to do with raw light; the manipulation of the exposure settings has to do with the nuances of your creative interpretation of that scene. After you understand the basics of exposure, you can begin to approach how the various tonal values spread out within the film record. Again, we'll work with the idea of stops to define what occurs.

The readings by the exposure meter define middle gray on the film recording scale. If you point the camera at a black wall, it will record on the film as a middle gray wall; if you point the camera at a bright white wall, it will also record as middle gray. This middle gray becomes the point from which all other tonal renditions are referenced.

Whatever the middle gray is, a stop brighter in the scene will record as light gray, two stops lighter as near-white, and three stops lighter as virtually white with some texture. More than three stops from middle gray will be very bright white (and will print as bright as the paper base). On the opposite end, one stop darker than middle gray will record as dark gray, and two stops darker will record as darker gray. More than two stops from middle gray will record as a dark tone with virtually no image information.

This may seem like just a jumble of numbers, but consider for a moment how this allows you to translate brightness to tonal values. By fixing the middle-gray placement, you determine the overall tonal value rendition of the scene on film. It also allows you to automatically compensate for certain

This exposure fell victim to the predominance of dark values in the scene. The metering system read the dark area and moved it to middle gray. This gives a good rendition of the shadow of the tree in the water but completely blows out (overexposes) the bright reflective leaves on the pond surface. This uncorrected print shows the results. Although some extra darkroom work might save this image, using the right exposure makes life much easier. There are two approaches to this exposure: Read the water and close down two to three stops (depending on how you want the water rendered), or read the bright leaves and open up two stops.

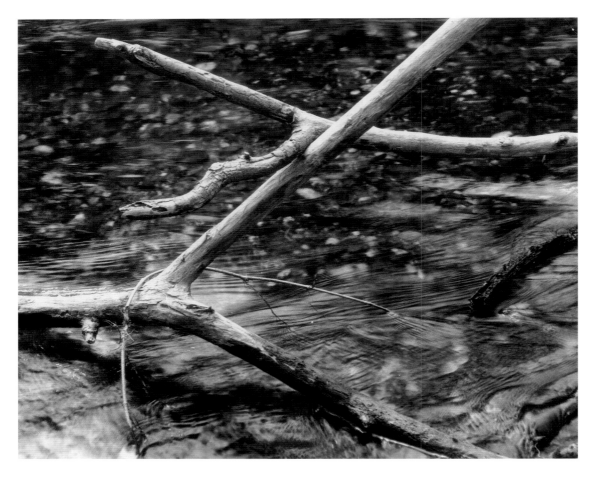

Proper exposure has distributed the values correctly in this scene. The exposure was f/5.6 at 1/60 second. The bright edges of the branches read f/16, or three stops brighter than the exposure (note that they render as very bright white); the brighter area of the water surface read at f/5.6 (middle gray); the darker parts of the branch and shadows read at f/2.8, rendering as dark areas on the image. That's how light and dark brightness values are distributed on the film's recording range.

subjects. Let's start with practical matters, then get into the creative applications.

Let's say that you are photographing a scene dominated by bright white. As you know, the metering system will average the brightness values to middle gray, so shooting at the recommended reading will render the white as gray on film. To counter this you add exposure by compensating (over-riding)—adding two stops for bright white, such as snow on a sunny day, or three stops for very bright white. So, if your reading is f/8 at 1/125 of a second, you shift to f/4 at 1/125 of a second, or f/8 at 1/30 of a second. At first blush, this doesn't seem to make sense—adding exposure to a bright scene.

But this goes to the heart of the matter: The meter doesn't care how bright or dark a scene actually is—it only takes the values and translates them to a middle-gray tone on the film's recording scale.

Conversely, if you are photographing a scene in which a very dark shadow predominates, your reading might be f/8 at 1/125 of a second. To place the values properly on film, you close down the lens to f/11 or perhaps f/16 at 1/125 of a second. This is often done to retain the mood of a deep, overcast sky, for example. You can do this manually or, with some autoexposure systems, by compensating plus or minus stops while shooting in automatic mode. Aside from reading from the right area within the scene, knowing how to compensate for scenes in which one value predominates is the key to successful exposure. Once you grasp the significance of this, you can begin to see how tonal values can be manipulated for creative interpretations of the light.

Now let's examine high-contrast lighting situations, where there's a big spread, photographically speaking, between the darker and lighter parts of the scene. We're in Shulman Grove high in the Sierra Nevadas, admiring the oldest living trees in the world, the bristlecone pine. The light above 10,000 feet is bright and hard; indeed, the deep-blue sky reads darker than the light reflecting off the ground (usually, the reverse is true). The curves and contortions of the branches and trunks make for fascinating pictures, but the contrast is very high.

Knowing that film can record only a certain range of light—about five to six stops—we are forced to make some decisions. The main decision is how to handle the extremes of bright highlights and deep shadows. Do we want texture in the highlights? Do we want detail in the shadows? If the former is the choice, there's a simple rule of thumb: Read the highlights (that is, take the exposure information from them), and open up

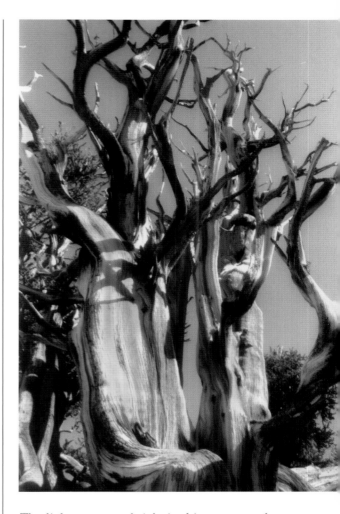

The light was very bright in this scene, making for high contrast between the shadows and highlights. To get the proper exposure, a reading was made from the brightest area on the tree where I wanted to record texture, and then exposure was compensated plus two and a half stops. This allowed for more exposure in the shadows; though some areas went black, it's a much better rendition than would result from taking an averaged reading or reading just from the tree and not compensating. Note that some areas of the tree did record too hot, and these were adjusted later when prints were made.

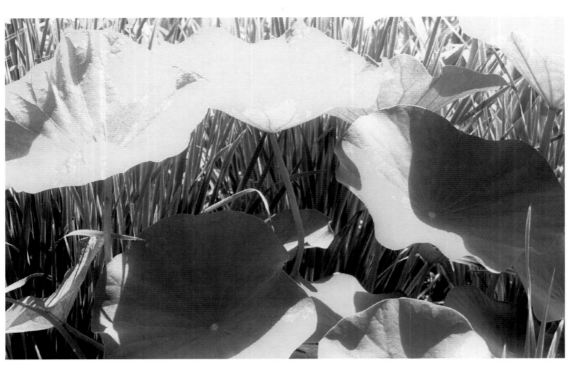

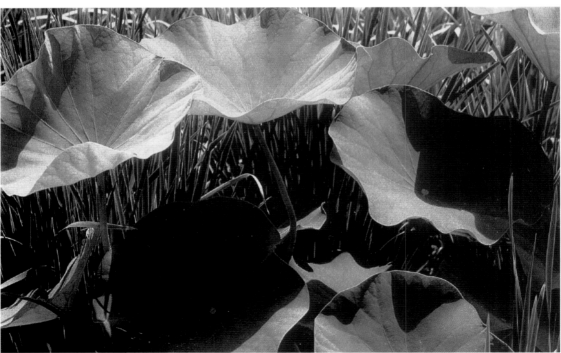

the lens about two stops. Let's say we get a reading of f/22 from the highlight. By now, we know that that exposure will render that area as middle gray on the film, and if that value is middle gray, the rest of the scene will be much darker. To "place" the tone correctly, we open up the lens two to three stops (to f/11 or f/8.) If we keep the setting at f/22, the shadows will "read" on the film as black. We could go with this exposure and create a very graphic rendition of the scene, but compensating the textural highlight reading (especially when it's such an important part of the scene) will give you a much better rendition overall on film.

Another choice is to read the shadow area—which here might be f/2—and close down the lens two stops to f/4. This will bring detail to the shadows, but the highlight areas will become harsh. We can correct for this somewhat when prints are made (there's more on contrast control in printing later).

There is another technique to compensate for extreme contrast, but this assumes that you have control over film development and that you will expose the entire roll in the same fashion. The trick is to take a reading from the shadow area in which you want detail (let's say that reading is f/2.8), close down two stops (to f/4), and then shorten

the developing time to help tame the highlights. This is called "pull" developing, and usually the first step in developing is shortened by about 20 percent. For example, if developing time is usually ten minutes, you develop the film for eight minutes. Thus you control the brightness values recorded through exposure and help control contrast through development. The catch is that the entire roll must be developed for this shorter time. Some photographers swap film as they shoot and mark it for different lighting conditions, then develop the film accordingly.

All the above is to help you manipulate tonality in virtually every scene. The key is to understand that from the meter reading of middle gray, you can shift the tonal recording by making creative decisions about what brightness value will be placed at middle gray and how shadows and highlights will be rendered.

As a final example, let's say that you're photographing in the deep woods and want to retain the mood. You take a reading from the shadowy area and expose at what the meter recommends. This will bring the darker parts of the scene to middle gray. Although this may not show the feeling of the place in the negative, you can always print it darker to achieve the desired effect. Or, you can close down two stops from the meter reading and record the scene on the film as you want it to look on the print. Either way is fine: The former records all the tones and awaits the final stage of printing to realize your vision; the latter records the scene as you see it on the negative and, although it may seem dark, is a true record of your artistic statement on film. The medium gives you the leeway to work either way.

Maximizing the Light on Film

Proper exposure techniques are key to great pictures. Sure, content is king, but being able to get what you see translated

When the light is extremely bright and the subject shows very high contrast, some tonal values may have to be sacrificed. This happens because extremes of contrast simply can't be recorded on film. The first (top) unmanipulated print shows a typical problem scene in which exposure for shadow detail results in a harsh, barely printable rendition. The second (bottom) shows how exposing for the shadows and closing down two stops yields a more printable version. In the darkroom, the brighter parts of the scene were "burned in" through selective exposure.

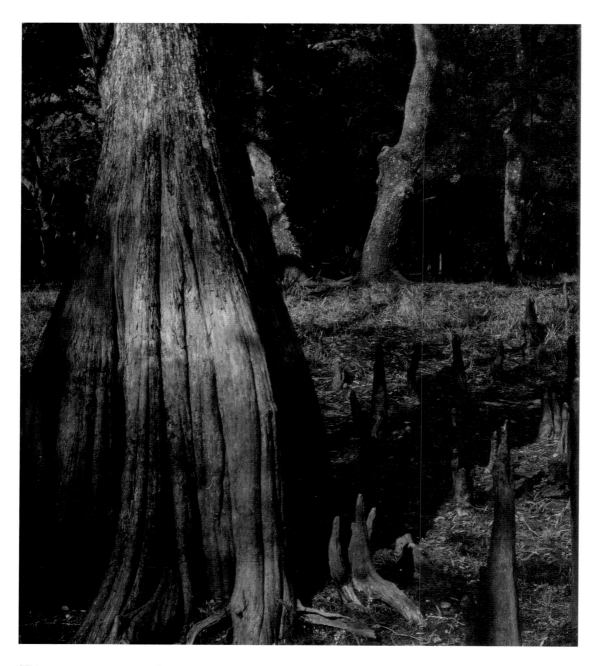

This scene appears on the print unlike it appeared in nature, showing how tonal values can be manipulated to attain a special sense of place. The first step is in exposure: The highlight with texture (on the center part of the tree in the foreground) is read; say the exposure is f/16. Rather than compensating to "place" this value correctly, the exposure is left alone. This makes the bright part of the scene darker, thus making the darker parts of the scene darker still. The print is then made even darker than the negative. This exposure and printing for the highlight value results in a moody rendition of an otherwise normally lit scene.

onto film is the start of photographic expression and creativity. If you've shot with color slide film, you know how critical exposure is: Overexpose, and you'll lose image information or get a washed-out picture; underexpose, and you'll get dark pictures. Luckily, black and white is a malleable medium—it has the flexibility to yield a wide variety of interpretations from the same scene and allows for some exposure miscues without too great a penalty. But the idea is not always to recover from mistakes; it is to optimize the light at hand to create a strong foundation on which to build images.

There's an old adage about black and white: Expose for the shadows, and develop for the highlights. This is just the opposite of color slide film, where you always have to be concerned about controlling the highlights. For slide film, that means biasing the exposure for the highlights. (Biasing here means basing exposure on the highlight reading and letting the shadows fall where they may.) The exposure procedure for black and white is almost opposite.

Following the adage "expose for the shadows" allowed me to record the play of bright light and detail in the shadows in the Badlands area of South Dakota. Here, I took a reading of the shadow area on the right (f/4 at 1/125 second), then closed down the aperture by about one and a half stops to between f/5.6 and f/8. Normally, I would close down two stops from the shadow reading, but instinct told me that a bit more exposure would give me more detail in the dark cliffs. As you shoot and see the results, you'll know when to bend the rules.

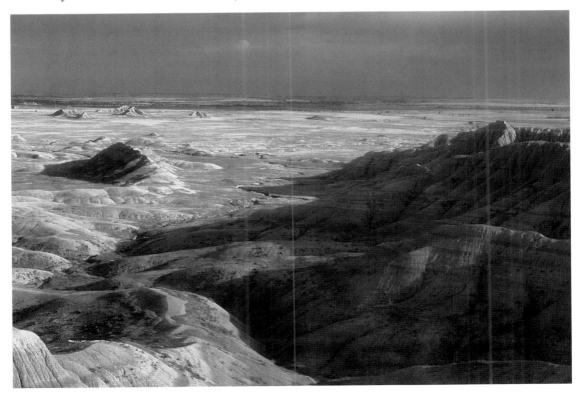

When photographing all but problem scenes with black and white, the rule is to expose for the shadows—in other words, find the darker values in the scene in which you want detail, then follow the exposure procedures already described. This ensures that the full range of the brightness values will be recorded on film and that you'll get a tonally rich image.

There are some catches to this rule. First, you do not merely take a reading of the darkest part of the scene in which you want detail and expose for that reading. This can be dangerous, especially if you are working in medium- to high-contrast lighting conditions. As mentioned earlier, the values work in lockstep, so exposing for the darker parts of the scene may drive the brighter parts too high on the film's recording scale.

The best way to work the shadows is as follows: Take a reading from the significant shadow area (the darkest part of the scene where you want detail) and then close the lens down (or shift the shutter speed faster) by about two stops. This takes the middle gray translation of the meter and places those shadow details at the proper place on the recording range. This should take care of 80 percent of your exposure situations. The only time this will not work is in high-contrast lighting situations (when the difference between highlight and shadow readings is more than five or six stops). When you encounter such lighting, follow the procedures already described.

I have to stress that exposure is both mechanical and instinctual; the rules can be bent somewhat, depending on the lighting conditions at hand. You will also react differently to various scenes and will want to try different techniques, depending on the situation. Experimentation and testing are key. As you work, you will develop an eye for lighting conditions and how to adjust for them. And keep in mind that black and white is a fairly flexible medium

and that miscues can sometimes be remedied in printing.

Learn the basics by first reading all the brightness values in various scenes, then calculating contrast and making a guesstimate of the proper approach. Test your instincts by shooting film at various settings and comparing the results with what you thought you'd get. Overexpose and see what happens; deliberately underexpose and see how you lose image information. Make "bracketed exposures" of certain scenes (that is, shoot plus and minus from what you thought was right or what the camera meter gave you) and see what happens. Try this in various lighting conditions.

As you do this, you will see how exposure and light interact and what exposure procedure yields the best results. As you study the images, you should begin to see how to get the most out of the light and how over- and underexposure affect the image record. You'll see the leeway of the film when improperly exposed and start to make judgments about how to handle light. This may seem tedious, but it will go a long way toward showing you how important proper exposure technique is to getting what you want on film.

Exposure Techniques Under Different Lighting Conditions

Let's examine how you can add nuances to the exposure techniques already discussed and bring an extra personal touch to images under low-, medium-, and high-contrast conditions.

Low-contrast light (change up to one stop) offers few problems, as whatever the meter reads will be brought to middle gray. To add some oomph to the image, my suggestion is to overexpose slightly to give more contrast to the negative. For example, let's say you're photographing on an overcast day. Scan the scene with the meter, and come up with two basic readings: f/8 and

This low-contrast scene was made under deep tree cover in the woods outside New Paltz, New York. The flat lighting needed a boost, so I took a reading and came up with f/8 at 1/60 second with ISO 400 film. I added one and a half stops (on the click stop between f/4 and f/5.6) to add some contrast to the negative. As a result, I increased differentiation between the tones.

f/5.6. Both exposure settings will give you a good negative, but shooting at f/5.6 will place the darker area on middle gray and bring the f/8 reading to a shade lighter than middle gray. If you want to add a stop to the f/5.6 (by shooting at f/4), you boost the two other values a stop, and add more density to the negative.

Medium contrast (about a three-stop difference) should also present few problems, as long as the meter is used properly. This means allowing the camera to average the values and keeping the rules of metering in mind (for example, watching for dominant values and "metering around" backlighting). If in doubt, meter for the significant shadow area, and subtract two stops from the reading.

High-contrast scenes pose the greatest problem. If the range of brightness values is greater than five stops, meter for the shadow area, subtract two stops, and, if possible, cut developing time by 20 percent. Alternatively, meter for the textural highlight value, open

This pond in autumn had a variety of colorful leaves floating on its surface. The yellow leaves can be differentiated from the others by the higher reflectance (brightness), which results in them appearing lighter in the print. But can you tell which are the red and green leaves in the photograph? To differentiate red from green, I added a red filter over the lens, thus adding exposure to the red areas in the scene, making them lighter in the print. We now can see that some of the leaves have turned partially red. Using filters adds tonal variety to scenes.

up two stops, and understand that you'll lose some image information in the darker shadow areas.

In short, metering is simple when you follow some basic rules and watch out for some of the pitfalls.

Filters

You might spend years working with color film without using a filter on your lens. With black-and-white film, you will get the most out of your work if you understand the use of certain color filters. This may sound like a contradiction, but if you consider that you are working with the brightness value of color and not the color itself, it may begin to make sense. By using filters, we help differentiate color (and thus increase tonal variation) because the monochrome image does not rely on the color record itself for that visual help. This, in turn, often has an effect on image contrast, or how tonal values relate to one another on film.

Color filters pass and block color light; the filter passes its own color and blocks its complement and, to a certain extent, other colors. When we speak of light, we are talking about the intensity of that light, which directly affects exposure on the film.

For example, if a subject that includes green and red is photographed without a filter, it may be hard to differentiate between the two colors in a black-and-white print. However, if a red filter is placed over the lens, it will pass the red light (or the reflection of red from the subject) and block the green (the reflection of green). Thus, the red will receive more exposure than the green, show more density on the negative, and print lighter than the green. Try this yourself, and you'll see that it's true.

Color filters are often used in landscape photography to affect the sky rendition. In northern New Mexico in the Valle Verde wilderness area, the afternoon sky is building over the hills. Billowing clouds race

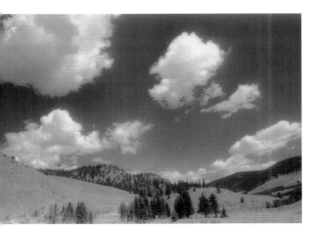 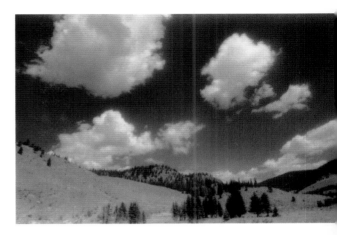

Yellow, orange, and red filters are great aids to working with sky in landscape photography. Taken in order, these filters darken blue and result in more contrast between the clouds and the blue background. (The effect is more pronounced with deep orange and red filters.) This scene was first photographed without a filter and then with a red filter over the lens. Note how the red filter also affects the tonal recording of the green trees.

through a deep-blue background. We first photograph without a filter, and the blue of the sky records slightly lighter than we might have desired. Why? Because some panchromatic films are oversensitive to blue; it records with greater density than in the scene and prints lighter than expected.

To deepen the blue and thus increase the contrast with the clouds and add drama to the sky, we place a yellow filter over the lens. This blocks the blue color by decreasing some of the density of its record, thus deepening the blue in the print. We replace the yellow filter with an orange filter to increase the effect, then replace the orange filter with a red filter. The result is an increasingly dark sky, with the red filter resulting in an almost black background that heightens the contrast between the blue sky and the clouds.

To help with the recording of color contrast in black and white, make note of the following:

Filter Color	Darkens	Lightens
Yellow	Blue	Red, Green
Green	Red, Blue	Green, Yellow
Red	Blue, Green	Red, Yellow
Blue	Yellow, Red	Green, Blue

Thus, if you are photographing a green leaf, a green filter will accentuate the contrast, thus giving more visual emphasis to its design. If you use a red filter to photograph a forest, the green leaves on the trees will become quite dark. In short, a filter causes subjects of its color to appear lighter in the scene, and complementary colors will appear darker.

A red filter is an absolute necessity if you are working with infrared film. Because the film is sensitive to infrared as well as all other colors, the red filter tends to block the other colors and pass the red and infrared light in the scene.

Another filter you might consider is a polarizer. This has no color effect but

Use a deep-red filter when working with infrared film, or the desired effect will be lost. This scene was made on a back road outside Taos, New Mexico, with a 24mm lens covered with a red filter. The infrared film was rated at EI 64; exposure was f/11 at 1/125 second.

works on the direction of light reflections. It can be used to eliminate surface reflections from water, deepen sky renditions, and reduce the harsh glare off sand. Polarizers are actually two pieces of polarized glass mounted in a filter frame. As you turn the outer glass mount, you see the effect of the filter right in the camera viewfinder; thus you can control the degree of polarization.

Neutral density (ND) filters also have no color effect; they are used to cut down the amount of light coming through the lens. Let's say you are photographing a river or waterfall in bright light and want to work with a very slow shutter speed to empha-

size the motion effect. Generally, a shutter speed of 1/8 of a second or slower will turn rushing water into a smooth, flowing mass. When you take your exposure reading, however, even at your minimum aperture—the narrowest opening of the lens—you come up with a shutter speed of 1/30 of a second. To get to 1/8 of a second, you have to drop two stops of light. If you place the proper ND filter over the lens, you can cut down the light and get the shutter speed required for the effect. ND filters come in powers, with higher numbers representing greater light-stopping ability.

Another filter you might consider is the so-called split neutral density type. This fil-

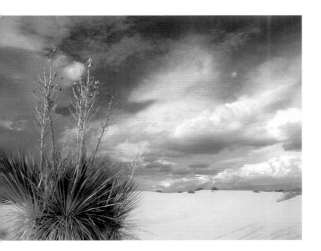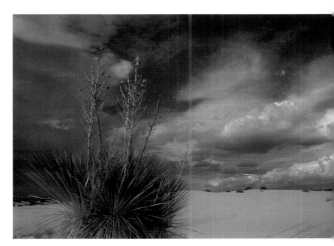

These prints display the effects of a polarizing filter in controlling reflections and sky rendition. The first is a straight shot without polarization; this can be worked on in the darkroom to gain a better rendition, but the bright and contrasty conditions can affect results. Using a polarizer controls harsh reflections and deepens the sky effect. When working with a polarizer, you see the effect right in the viewfinder. With color filters, you have to visualize the effects without the benefit of a preview.

ter either graduates density from the top to the middle or has a single density from the top to the middle of the glass. These filters are often used to block light from the sky while admitting all the light from the ground and are useful for "straight" hori-

zons. Not every landscape offers such a neat separation, so these filters are handy only under a specific set of shooting conditions. As we'll see, when prints are made, some of these contrast problems can be handled in the darkroom.

Completing the Vision

The end product of most black-and-white work is a print. That print can range from snapshot size to a wall-filling mural. Most of us work with something in between, an 8×10, an 11×14, or a 16×20 image. Whatever the size, the printing stage can be as important, at least in terms of interpretation, as the choice of film and exposure. It's in printing where the tones we've recorded on film are faithfully rendered or where we begin to make other choices that enhance the moment, mood, or subject matter. Prints are sometimes made long after the exposure; this leaves room for further contemplation of the subject or for a reinterpretation that speaks to our current way of seeing the world. The negative, then, becomes raw material for our creative expression, a part of the process that is completed when a print is finally made.

The Contact Sheet

To help in the process, I suggest that you have a contact sheet made of every roll you shoot (or a contact print of each large-format negative). A contact sheet is a ganged proof of all the negatives on one sheet of printing paper. Although you could read the negatives to see what you've got, a contact sheet is a positive record that, when stored along with the negatives in a sleeve, makes retrieval of those negatives for printing at a later date much easier. The contact sheet also allows you to make some editing and basic printing decisions before you go into the darkroom and print the image yourself or send it out to a lab.

If your negatives are consistently exposed, you should be able to read most of the images on the contact sheet. If not, you may have some frames that are lighter or darker than others. Don't worry because these can be sources of good prints, as well (unless, of course, the image is hopelessly under- or overexposed). If the positives are "all over the map," check your exposure procedures. If necessary, you or the lab can print two contact sheets—one darker than the other—to give you a read of all the images.

The contact sheet will give you a fairly good indication of what you've shot. Inspect the images with a loupe (a magnifier for reading negatives and prints, available at photo supply stores) or by eye. Start by checking out composition and framing, and pick the best from the series. You can also start the process of cropping here, which means selecting areas of the composition from which you want to make the final print. You can visualize cropping with two pieces of small, right-angled cardboard laid right over the image frame. Use a grease pencil to mark those frames you'd like to print.

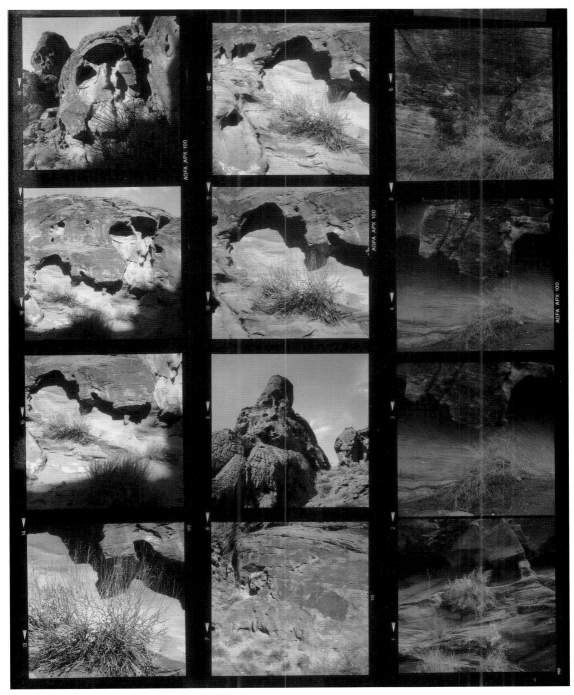

A contact sheet, such as this one from a medium-format camera, allows you to view the entire roll on one sheet of paper and provides a positive record of the shoot. This is a more efficient and economical way to have film processed. Store contacts and negatives together for easy reference and retrieval.

Paper Contrast Grades

The versatility of black and white is expanded by your ability to make prints on papers with a range of contrast renditions. These grades go from very low contrast to very high contrast. You can heighten the contrast of the image by working with the higher-contrast grades—such as a #3, #4, or #5 grade—or lower the contrast of the image by working with a #1 or #0 grade. A "normal" grade, which will render the contrast of the original negative faithfully on the print, is a #2 grade. Papers today are sold as variable-contrast stock; through the use of filters placed in the enlarger's light-

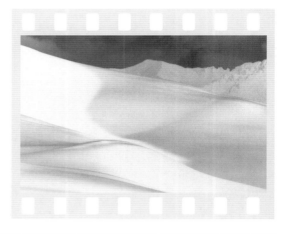

By working with paper of different contrast grades, you can alter the look of negatives when going to print. This allows you to increase or decrease contrast or to match the negative with a grade that gives you the fullest tonal range possible on the print. This negative is a bit "thin," or underexposed. When printed on a fairly high-contrast paper (#4 grade), the contrast between tonal values is accentuated.

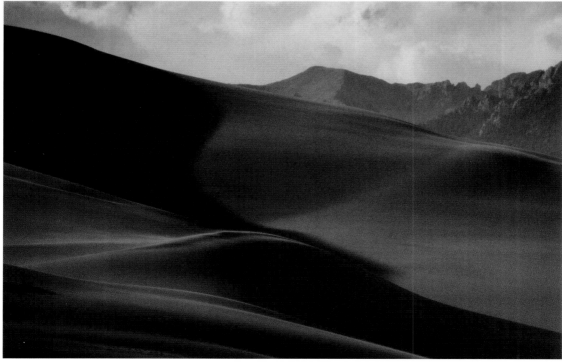

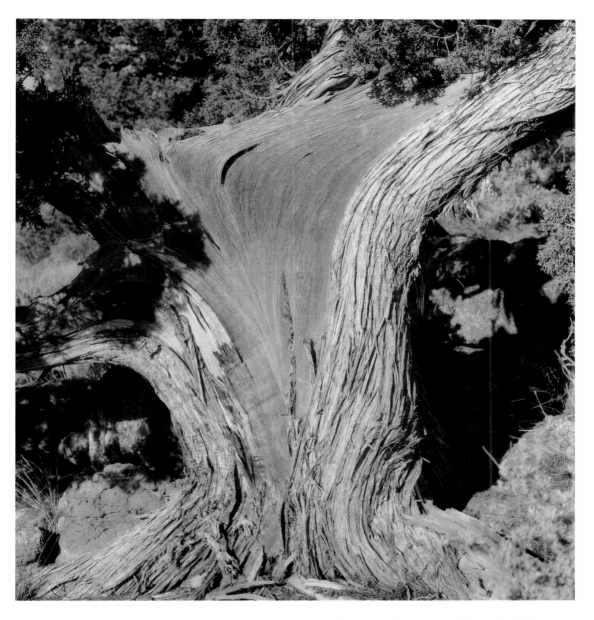

The negative from which this print was made was very harsh and contrasty. To get the fullest possible tonal spread, the image was printed on #1 grade paper. This tamed the highlights and improved the rendition. There is a price to pay, however, because printing on a lower-contrast paper may suppress some of the potential tonal richness in the darker parts of the images.

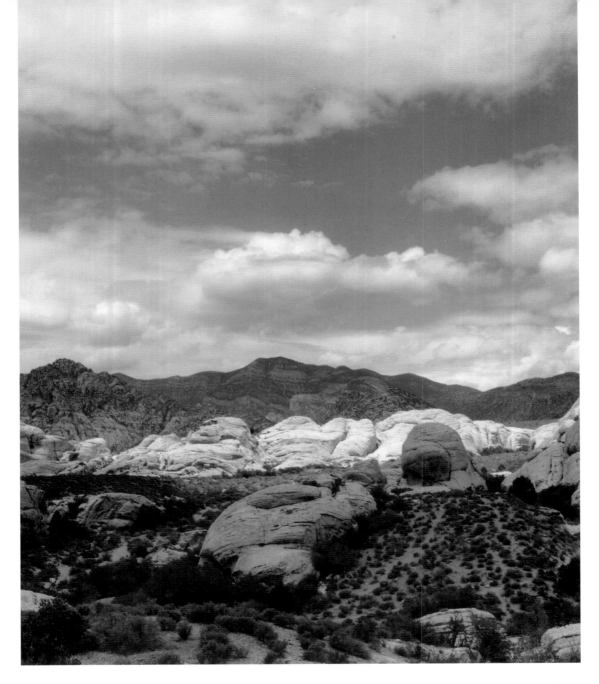

This scene, made in Red Rock Canyon outside of Las Vegas, Nevada, was printed using a split-contrast technique. In the original negative, the sky was considerably more contrasty than the ground. To blend the two into one mood, the ground was printed using a filter that evoked a "normal," #2 grade rendition. The sky was then printed with a filter that made it less contrasty—a #1 grade. The print was made on a variable contrast paper that allowed for this technique. The beauty of black-and-white printing is that you have many tricks and techniques at your disposal to help you make expressive images.

source path, one paper can be made to yield the entire range of grades.

Why would you want to alter the contrast of the negative on the print? There are two reasons: to correct a problem in the negative, usually to heighten or lower contrast, or to enhance or change the image for creative purposes. Contrast correction can be a great aid for slightly underexposed or overexposed negatives. Lack of contrast in the original can be punched up by printing on higher-contrast paper. Conversely, if highlight areas have been overexposed and look harsh on the print, they can be tamed somewhat by printing on a lower-contrast grade than normal.

Each of these corrective procedures has a price. Just as tonal balances on film work in lockstep, contrast changes in a negative affect all the tonal values in the print. If, for example, you are taming high contrast by printing on a low-contrast paper, all the other values will drop in contrast, as well. This can mute certain parts of the image.

Printing Techniques

There are a number of darkroom techniques that can help with this contrast problem. One is split-contrast printing, in which areas of the print are subjected to different contrast treatments. Let's say that the sky and ground require different contrast grades—

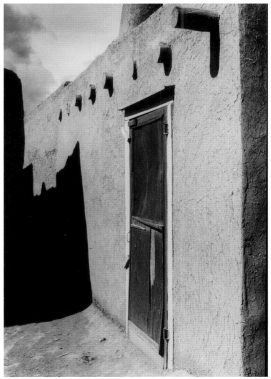

When making prints in the darkroom, a "test strip" is used to make decisions about exposure time. Each section of this print shows the effect of different enlarger exposures— here, they are in three-second bursts, so the effect is cumulative as exposure is made. Once the test print is finished, final exposure decisions can be made. This also allows you to see the effect of time on the print and how different times allow for different image interpretations. The exposure chosen here was nine seconds. IMAGE AND PRINTS BY GRACE SCHAUB

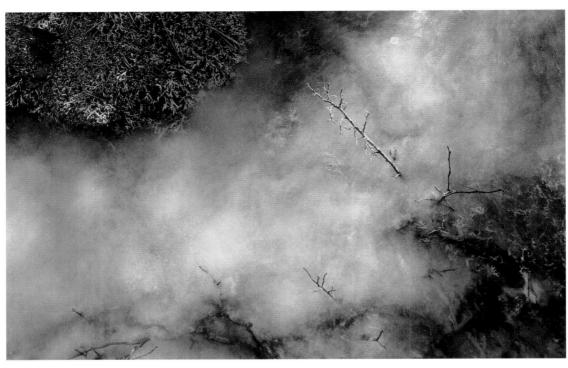

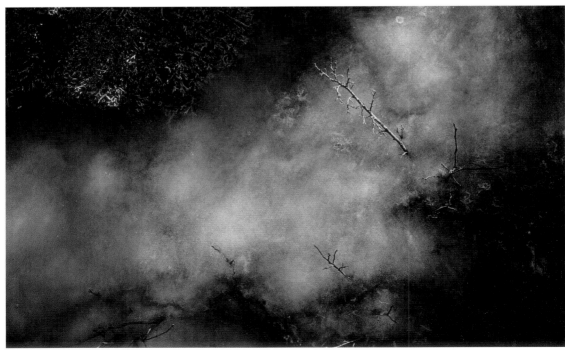

the sky needs a lower contrast to control the clouds, and the ground needs a greater contrast to make up for slight underexposure. Each portion of the image can be printed through a different color filter, with the edges feathered to make for a better blend. This technique takes some experience to get right, and I mention it here to give you a sense of the facility of the medium.

Another way to affect the tonal rendition of a print is through selective density adjustments, known as "burning" and "dodging." Burning is adding more exposure to select areas in the print. You do this by allowing the light from the enlarger to affect only those areas that require more density, using your hands or a cutout in a piece of cardboard to direct and hold back the light. This can be an effective way to control hot highlights or to darken areas of a print for creative effects. Dodging is holding back light

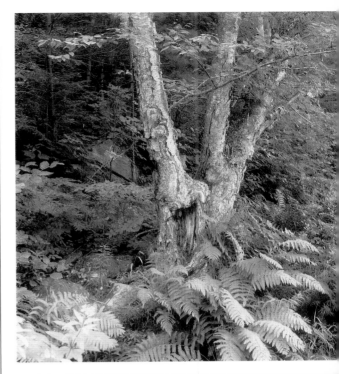

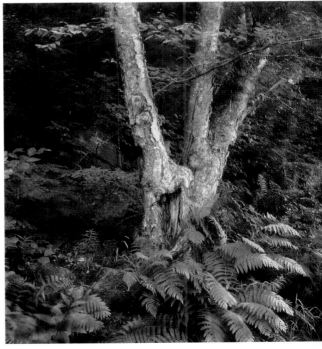

Burning and dodging are effective printing tools for enhancing images. These techniques also call your power of previsualization into play, as you can alter the entire mood of the image through their application. The top image on the facing page is a raw, unworked print of moss, ice and twigs frozen in a stream. By burning down the edges (adding selective exposure when the print is made), we deepen the mood and transform the image so that it appears that bare trees are coming up through a fog (bottom). The photos on the right, show how dodging was used to bring out details in the tree and to make it stand out from the forest floor. The uncorrected print from the negative (top) shows open tones throughout the image. To add drama, the tree was dodged (exposure was held back) during part of the overall exposure time. This lightened the tree in relation to the rest of the image (bottom).

Computer imaging opens a new door for black-and-white photographers. Virtually any task you can perform in the darkroom can be accomplished with a computer and image-manipulation software. The negative of this image (above) was rather flat (low in contrast). The negative was transferred to a photo CD, and with Adobe Photoshop software, just a few clicks and movements achieved the right contrast rendition. This barrel cactus (facing page, top) got the treatment in a special-effects part of the program known as "posterization." This result would have taken hours in the darkroom; the computer time was about three minutes. The blossoms of this tree (facing page, bottom) were backlit, but the effect in the field did not fully translate to film. To add some romance to the scene, the image was run through a trick known as "diffuse glow." Computers are just another tool for imaging; they neither replace your eye and instincts nor substitute for basic image techniques. They do, however, make life more interesting for the photographer.

from select areas of a print, done to open up shadows or modify the effect of the overall print exposure.

Creative contrast decisions include working in very high contrast to achieve a more graphic effect, by emphasizing line and texture effects. You can also work "soft," or in lower contrast, to enhance, for example, a fog-shrouded scene. Again, you make some tonal sacrifices when you deviate from the normal contrast rendition, but this doesn't mean that such choices aren't effective. In the end, technique is there to serve communication.

If you do your own darkroom work, choose a few negatives and make a series of

contrast-grade prints from each image. This will give you a catalog of effects and serve as a reference for future creative and corrective decisions. If you work with a lab, the terms to use are higher or lower contrast, or printing "harder" or "softer." In most cases, the lab will work with you to get the contrast-grade rendition you desire.

The lab can also be directed to do burning and dodging effects. Use an acetate pasted over the print with burning and dodging indicators, with a plus (+) sign for burning and a minus (–) sign for dodging. Although subjective, these indications can help you get better prints from custom labs.

Paper Stock and Color

I mentioned earlier that black and white is a bit of a misnomer, as we are dealing mostly with shades of gray. Monochrome is also a bit misleading, as most printing papers have a color cast ranging from warm (brownish blacks, with creamy whites) to cold (bluish blacks, with a bright white base). This image color can be enhanced by working with different developers.

You might choose to have certain scenes printed on a warm-tone paper, such as photographs of the deep woods or a barn set amidst the rolling hills of Vermont. Others may benefit from the cold-tone treatment, such as winter images or those with a more modernistic feel. There is no rule of thumb here. Most of Ansel Adams's images were printed on cold-tone papers, whereas the pictorialists' nature images were printed chiefly on warm-tone stock.

Virtually every paper manufacturer offers a wide variety of papers, with surfaces ranging from glossy—a smooth sheen—to matte—a flat, nonreflective surface. You can even find stipple surfaces, which are similar to watercolor papers, that may be useful for hand coloring or unique presentations. Papers also come in different weights—from single ply to heavy, so-called art, stocks—

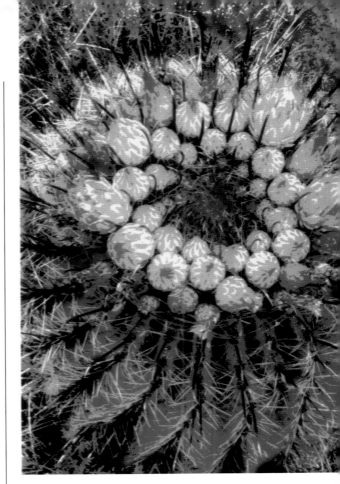

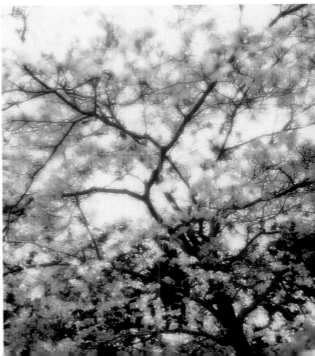

that have an effect on the look of the print, as well. Most manufacturers offer sample books featuring their range of printing paper stocks and colors.

Toning and Hand Coloring

Toning is another way that "color" is added to a black-and-white image. Toning involves treating the print in a chemical bath after it has been processed. This converts the silver in the paper to a compound of silver and sulfide, selenium, or some other metal. This accomplishes two things: It makes the print more permanent (impervious to outside forces that can tarnish or cause the silver to tarnish or fade), and it adds a wash of color to the image.

In the past, toning was a common practice. The modernists, however, viewed it as a sentimental approach, so it fell into disfavor. Now it is an attractive option for adding mood and emotion to images. You might want to tone a nature scene sepia or add a blue tone to wintery subjects.

Another option is to add color through the use of oils, pencils, and pastels. Hand coloring, as it is known, was used for portraits and certain wall art prints to make up for the deficiency of color in photography. When color became widely available in the mid-twentieth century, hand coloring fell into disuse but is again gaining in popularity. Hand coloring is an art that can be used sparingly for a surprise touch of color in an otherwise monochrome image, to cover the entire print in "true" color, or to add odd color for a more surrealistic effect.

Digital Options

An intriguing new trend in black-and-white printing is the use of computer-aided imagery. Although most people still photograph using film, an increasing number of photographers are using the computer to make prints. This eliminates the need for a darkroom (a major commitment of space) and allows for desktop creativity that offers as many options as the classic darkroom work space. The easiest way to get involved with computerized black-and-white imaging is to have your negative scanned onto a photo CD. This digitization process can be done by a local lab, or you can scan the image at home with a scanner connected to a high-capacity disk.

Once digitized, the images can be shared on the Internet or processed and printed as you would with conventional materials. A good-quality printer is key, as is familiarity with image-processing software. But all the printing controls available in the darkroom are easily mastered on the computer.

Whatever path you choose, keep in mind that taking the picture is often the first step in a process that allows you to further interpret and enhance the black-and-white image as you go. Learning about those options, and keeping the possibilities in mind as you photograph, completes the circle of creation that begins with previsualization and ends with the making of the final image. If you keep the big picture in mind as you work and consider all the paths you can follow, you'll begin to appreciate the creative and expressive possibilities of this medium.

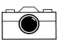

Photo Diary

It's been said that outdoor photography is a form of hunting and gathering; that it appeals to our latent nomadic nature; that it gives us a way to relate to the power and glory of the natural world. I can nod in agreement now, but I never gave it much thought when I began to photograph on trips, hikes, and journeys some thirty years ago. Frankly, the bug bit me before I had the inclination to rationalize my activities.

Working with a camera outdoors gives me a way to express myself. It gives me a way to hold on to a realization that occurred to me on my travels and to reinforce perceptions that seemed interesting at the time. The photograph ennobles the moment and crystallizes a passing glance, or a deep recognition, into a more permanent form. Although these visual notes to myself are not always as profound as I thought they were at the time, many remain meaningful to me today.

Photography also gives me an opportunity to consider the aesthetic matters of the visual senses—about light, shape, surface, and time—and to express those considerations in accessible terms. These are the elements of thought that go into developing perception, just as music teaches us more than a few simple tunes. It also is a way of expressing personal and universal symbols—it gives that which is depicted an existence in both immediate and generalized terms. Think of Egyptian hieroglyphics and Chinese ideograms, written forms of communication that embody both the spoken word (the utterance that evokes a thing) and the idea of a thing in its very form. A photograph can have equally expressive power—it speaks of the thing depicted and opens a chain of associations that, depending on the individual making or viewing it, can lead in many different directions.

I am also fascinated by the rhythm of picture taking in the field and how it feeds the creative mind. I tend to run hot and cold—I'll shoot intensely for an hour, then hang out, visually speaking, for the remainder of the day. This may have more to do with the light and the subject at hand, but it also speaks to being in the "zone" of perception, a mind-set in which light and shadow make a beeline into some artistic center of my mind. There's also the importance of visual silence, of having the patience to wait as long as possible before shooting. Often, I'll pass three or four potential shots before I begin, then start to work when I just can't hold off any longer.

That's what happens—ideas, subjects, and designs begin to pop up, motioning for me to recognize them with my camera. True, there must be time and space for all this to occur. But subjects begin to wink and nod; sometimes they grab me by the ankle. I may be walking in a certain direction and find nothing and then just turn my head to the right, and there it is.

Achieving a sense of what makes a good photograph is probably the greatest photographic challenge we face. This gets tied up with the need for approval, the need to justify the time and expense, and other personal hang-ups that just get in the way. Working through all that is part of the process, as is discovering what a personally satisfying photograph means. I take the chance that some of my favorite images are totally puzzling to others. My responsibility is to be honest to myself and to execute my images with the most skill at my disposal. Beyond that, I understand that personal attachment to some images may be my only justification for creating them, that the stories that go with them may be the only reason I choose to make them into prints.

I've also come to realize that my early instincts are perhaps my best, and that pursuit of ideas that come in a rush may be the best course. Derivative images, those that chase passing fads or that emulate the ideas and forms of others, are instructive but not always true. Some emulation can't be avoided; indeed, when you're starting

out, working through the eyes of others can help you gain a background in the visual history of the craft. But continual conscious copying, and filling in the spaces drawn long ago by others, will not stand the test of time. You have to find your own way.

The amazing speed with which a photographic image is recorded has never kept me from considering the craft a viable medium for artistic expression. The wonderful aspect of photography is that when the muse hits, you can act on it without wasting too much time. But there are matters of ownership and "earning" the ability to express yourself in this medium that should be considered.

For example, picture a postcard of the ceiling of the Sistine chapel in the Vatican. Michelangelo suffered long and hard to accomplish the masterpiece, but the photographer can record it in a second or less. Of course, what's missing from the photographer's Sistine Chapel is the process of its creation and the ownership earned by the blood, sweat, and tears—and the deep satisfaction—of its creator. When we photograph a tree, we are also copying creation, though we often have the hubris to claim it as our own. We have no more to do with the tree's creation than we do with the painting of the Sistine chapel.

Given that we can capture and hold only what is external to us, what is the process and creative nature of photography? The process is an evolution of the unique way in which each of us sees the world. It is the ordering, juxtaposition, and framing of subjects and how these elements come together in an image.

We are always filtering energy and defining—psychologically and physiologically—what we perceive. Without these reality filters, we could not move, we could not survive. The universe is just too overwhelming. When we begin to consider aesthetic matters, we apply some of these filters to a con-sideration of the arts and how we relate to them as defining our place in the world. It's a perfectly human thing to do.

Photography, then, becomes a vehicle for such considerations, one that relies on external subjects and their ordering as the method of expression. A painter can go to a ballet, sit there and absorb the event, and then go home and create a painting, be it literal, representational, or an abstraction of the motion itself. Painting involves internalization and then realization on canvas. If a photographer goes to the same performance and does not take a picture, there will be nothing to show for whatever occurred internally and no artistic evidence of having experienced the event. True, the photographer can take in the experience and apply it later to the movement of beach grasses in the wind or to the rhythm of forms in a landscape, but photography is about the moment and the creative reaction it sparks.

Thus, a photographer must interact with the subject at the time of the contact and must act on the impulse to create at the moment it occurs. Further action can be taken when the film is developed and prints are made, but there is no internalization without immediate action. And without consideration of what will stimulate that action, there can be no intent to create. Lack of intent can lead to loss of meaning and result in images that are no more than hollow documents of a time and a place. They hold no meaning for the photographer, so how can they touch others?

That, then, is part of the process of photographic creation—a consideration of light, tone, contrast, and subject matter, balanced with an understanding of the tools of the craft, that will lead to action when the photographer and subject meet. This immediacy becomes a summation of otherwise disparate thoughts and feelings that result in a photograph. The act of creation is a 1/4-inch motion of the right index finger. What

comes before is preparation and a readiness to receive the impulse; what comes after is a refinement of that moment achieved by applying the tools of the craft.

With these meanderings in mind, consider the following reflections as my way of putting the accompanying images into some context. I do not intend to burden the images with meaning but to relate a personal process of creation and a description of the time and place in which those moments occurred.

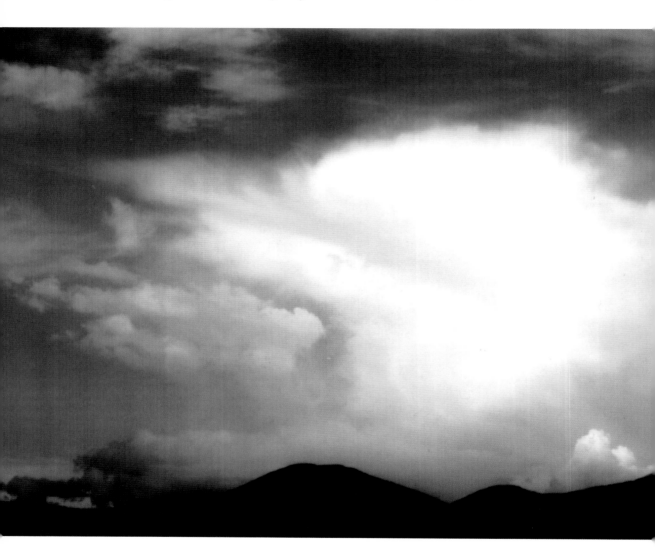

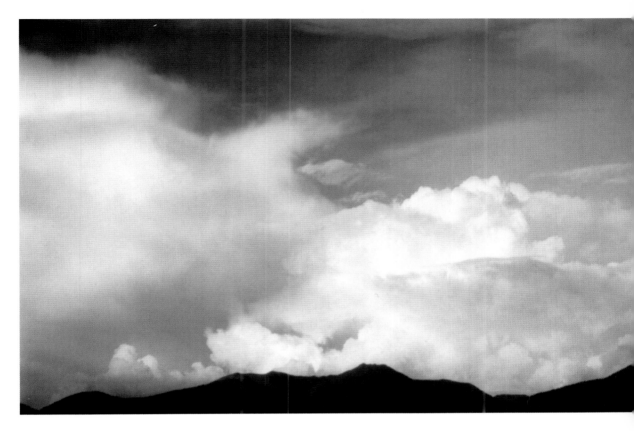

Clouds, Taos Mountains, New Mexico, 1997. *Pentax 6×7 camera, Agfachrome Scala 200 black-and-white slide film, 150mm lens, red filter. Exposure: f/5.6 at 1/60 second.*
 I always use a color filter when photographing clouds. This differentiates sky tones, and the red filter renders blue quite deeply on film. The exposure reading was made by pointing the camera directly at the subject; no exposure compensation was required. These photographs (above and left) were made from my front yard, where the show is always playing.

They form in mists and vapor and foretell the days to come. They shape themselves into our dreams; we project our thoughts into their ephemeral forms. They swirl, dissolve, tower above us; they run headlong into mountains and scamper through the passes; they are metaphor for time, cycles, and seasons. We look in wonder at the landscape of the heavens, at dragons pulling chariots, whales breaching a tossing sea, and a traveling salesman in his bowler hat.

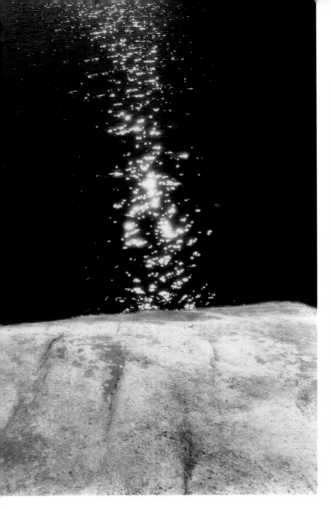

Reflections, Goose Pond, Pharaoh Wilderness, Adirondack Mountains, New York, 1997. *Nikon 35mm camera, Kodak T-Max 400 film, 24mm lens, yellow filter. Exposure: f/16 at 1/125 second.*

The exposure reading was made from the water surface and closed down two and a half stops. The intent was to deepen the tonal value of the water so that the highlights would stand out in contrast. The rock face was slightly overexposed and was "burned down" to a chosen tonal value during printing.

There are days when the clarity of light is startling. This may occur at any time but usually occurs in the northern winter, when the haze is chilled away, and the sun sits at a lower angle in the sky. This is the light that skins your eyes, that puts an edge on the slightest texture, that makes brilliant any translucent object and places halos around those that are more opaque. It's the clear light of vision.

My wife, Grace, and I recently experienced such a day on an autumn hike through the Pharaoh Wilderness in New York's Adirondack Mountains. The trail to Goose Pond moves gently through a canopy of maple and pine. As we walked, we noticed that when passing through the pine groves, all was blue; as we passed through stands of maple, a warm amber light filtered down through the turning leaves. Blue, amber, blue, amber, and then an occasional opening in the trees where a hard-etched light broke through. If we sat long enough, we could see the light move as the sun traced its path through the sky; the light moved slowly, like a spotlight following a snail.

After a two-hour stroll, we came to the pond and rested on a rock. Soon the sparkles caught our eye, the spectral highlights kicking off the crests of the gentle, windblown waves. Seeing them made me understand why poets saw fairies in the woods, dancing sprites of light that played with the wind. The light penetrated the clear water, and we saw sunken branches and fallen trees that created thoroughfares for the trout and killies that swam by. Fallen leaves on the pond formed intricate patterns and were slowly blown to shore, where they bunched together like junks in Hong Kong's Aberdeen Harbor. There were no geese on Goose Pond that day, but it was filled with and surrounded by life that stirred as we quietly sat. As I sit here now writing this, I know that we sit there, too—silent, alive, under the crystal-light sky. The light seems to stream from the head of the rock, like the enlightenment heading for the sky from the top chakra. Some of the spectral highlights blaze like the sun from which they were born.

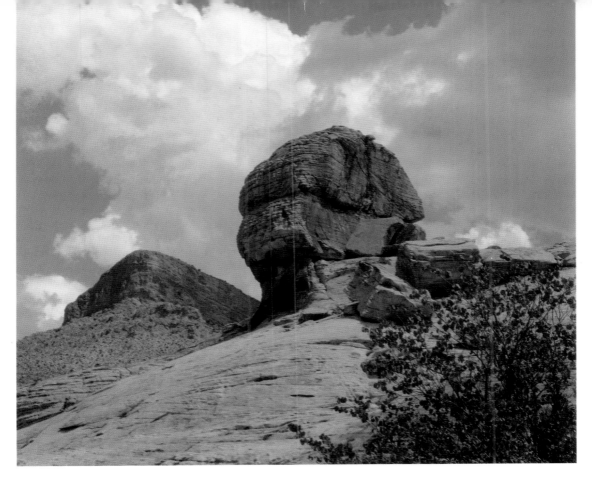

Sphinx and pyramid, Red Rock Canyon State Park, Nevada, 1997. *Rollei 2.8E twin-lens reflex camera (medium format, 120 film), Ilford Delta 100 film. Exposure: f/11 at 1/125 second.*
 This camera has no built-in meter, so I took a spot reading off the ground with a Sekonic meter. The reading was the same as the exposure. The sky was deep blue, with rolling, dark clouds to the left. A shaft of directional light provided the illumination for the rocks and foreground.

The Sphinx of Thebes asked all passersby a riddle: What creature walks in the morning upon four feet, at noon upon two, and at evening upon three? Get it wrong, and the Sphinx killed you. Oedipus guessed the riddle, and the Sphinx slew itself, and Oedipus became king of Thebes. The answer (should you happen upon a sphinx in your travels): man, who as a baby crawls on all fours, later walks upright on two legs, and in old age walks with a staff.

This sphinx presented itself in Red Rock Canyon outside Las Vegas, with an accompanying pyramid in the background. I went there after a few grueling days in Las Vegas covering a photographic trade show for a magazine. Though not as profound as the Thebian version, nor threatening such dire consequences for a wrong answer, this sphinx posed the question why I was spending so much time in that desperate city expending energy on details of commerce when miracles such as this sat just an hour away. The sphinx sits there still, as does the question.

Emerging face in the rock, Zion National Park, Utah, 1985. *Minolta X-700 35mm SLR, Kodak Tri-X Pan 400 film, 28mm lens. Exposure: f/8 at 1/125 second.*

The range of values made for an easy exposure, as the center-weighted meter averaged the values and delivered a full range of tones. When the print was made, the edges were slightly darkened to emphasize the "face" in the center.

I look at something, and it looks back at me. Sometimes it looks through me or passes me by, but I register something by its presence. I take it in and allow it to change me, if only for the brief moment of its recognition. It speaks to a part of me that does not always hear. It teaches me something about the world, about myself.

I anthropomorphize—I see human forms in inanimate objects. I'm a pantheist and see fallen idols in the stone. Gods, devils, and angels of dead civilizations are fossilized in rock, tied in the exposed roots of trees.

There are places of the dead, spirits in the woods, beings whose sacraments are the light and shade. Their silence speaks to me.

I feel odd that they should appear to me. They reveal themselves at low tide, emerging from the sand, revealed by the wind. They are formed by the wind, the ice, the movement of the earth as it rises and falls. They wallow in ponds, live in river rocks, and play hide-and-seek as the sun moves through the sky. Whose fallen idols are they? What messages do they bear from their lost worlds?

Guardian Rock, Chaco Canyon, New Mexico, 1993. *Rollei 2.8E (medium format, 120 film), Ilford Delta 400 film, 80mm lens. Exposure: f/16 at 1/250 second.*

The highlights on the rock face were read with a Sekonic spot meter; then exposure was compensated plus one and a half stops. This guaranteed texture in the bright highlights. The shadows went deep, as this was a contrasty lighting condition, but the deepness of the shadows served to accentuate the forms. When the print was made, the formation in the background and the ground in the foreground were printed darker to accentuate the main subject.

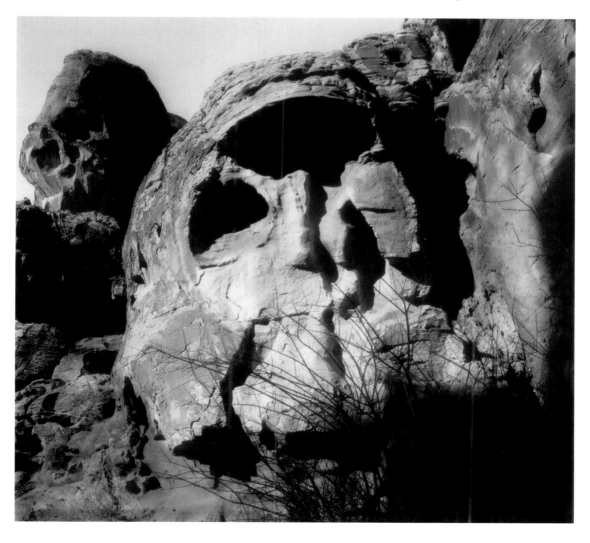

Near Fish Eating Creek 1 and 2, the Everglades, Florida, 1994. *Rollei 2.8E (medium format, 120 film), Ilford XP-1 chromogenic film, 80mm lens. Exposure: f/16 at 1/60 second.*

The Rollei 2.8E is a meterless medium-format camera, so I used a handheld Sekonic incident meter and took a general reading of the light falling on the open clearing. With an incident meter, you measure from the subject pointing toward the camera, with the meter angled at about ten o'clock (don't point it at the sky). I kept the one reading for the duration of the session and shot two twelve-exposure rolls, stopping only to reload.

There are times when the photo bug really bites me, when wherever I look, a potential photograph catches my eye. It may be the quality of light or the naked gaze engendered by the unfamiliarity of the surroundings. It may be just the startling nature of the subject itself that goes directly to the creative part of my heart and mind. Sometimes—rarely—it can be all three.

This occurred recently on a photographic trip to the heart of the Everglades with the Palm Beach Photographic Workshop. This area is off-limits to the national park crowds, about an hour's drive from Fort Meyers, Florida. I walked along a trail with Grace, who had been at this site a year earlier and had encouraged me to join her this time. We walked until we came to an open area—on the left was a field filled with wild iris, on the right a circular clearing surrounded by live oak trees. The trees held the same abundant sense of life that thrived in the rest of the region; every square inch was fought for by some fascinating lifeform. Vines climbed limbs dripping with Spanish moss; air plants grew in nooks of the trees wherever water gathered. Every direction held picture possibilities—the limbs etched designs that broke up the frame; leaves and vines interconnected to form intricate patterns of life; darks and lights merged and jumped out in contrast; spirit faces appeared. I felt that I was in the middle of the circle of life.

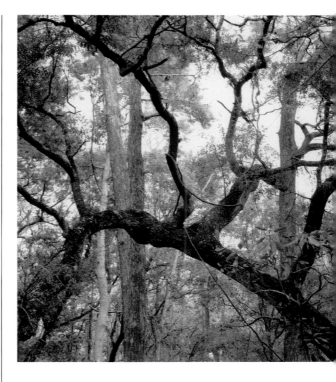

This is the moment that defines why I am engaged in photography, when my eyes open and one image after another presents itself. It's when subject, light, and my eyes align onto film.

Although I'm never sure whether these moments of intense shooting will stand the test of time, I've always derived a good deal of satisfaction from these frames. Out of the twenty-four, I felt very good about eight or nine. More important, the images hold the memory of a magical moment that still reminds me of the real excitement of photographic involvement.

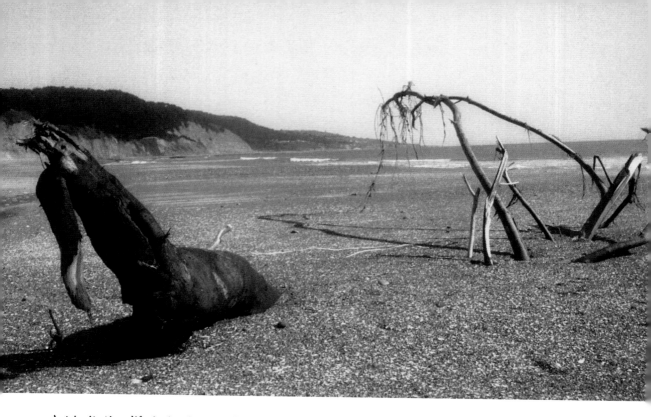

Art imitating life imitating art: beach sculpture and tree, Orient Point State Park, Long Island, New York, 1992. *Nikon F3 35mm SLR, Kodak Tri-X Pan film, 24mm lens. Exposure: f/16 at 1/250 second.*

To make this exposure, I took a reading off the sand, which set it as middle gray in the film's recording range. This set up all the other tones as desired. I used a 24mm wide-angle lens and set the aperture at f/16 to ensure sharpness from foreground to infinity in the scene.

There are certain beaches that accumulate fascinating debris, that tell a story about life by what's left on shore. These are beachcombers' delights, and they hold secrets that are revealed to the seeking eye. I have fond remembrances of the Oregon shore, with its wild and tortured driftwood, and of Torrey Pines State Beach in southern California, an oft-visited favorite. This photograph was made at Orient Point State Park at the tip of Long Island, in an area near its "sunken forest." This tree trunk lies buried in the sand, the remnants of its existence revealed by wind, tide, and shifting sand. The form that echoes its existence was created out of driftwood by a beach-combing sculptor or sculptors; it is a delicate mime of the tree it seems to shadow.

This image evokes the hand of humanity as it draws on and emulates the life around it. It is about sensitivity to the graces, and harshness, of nature and about seeking elements that re-create its substance and form. The fragility of the sculpture is such that a strong wind or wave will bring it down, yet the statement is still made. Thus, creation is an act of will made in the face of inevitable destruction; it is an assertion of our presence in the knowledge that it is temporal, at best. Years later, the image of this act of creation still stands as a testament to the determination of the creative spirit.

We inherit symbols from our culture and attach meanings to them that give order to life. We accept these without question—their power is cumulative, their true meaning often buried in the ages. But we should question where they come from and try to understand why they communicate with such power, with such silent eloquence, the deeper meaning of the world. Numbers are symbols, with zero being emptiness, the void; one being the self facing that void; two being the other that engenders self-consciousness; and three being the sum of one and two, the creation, the resolution of the dialectic. If numbers have an end to their progression, it is at infinity, the place beyond counting, the universe, where parallel lines meet.

Our symbol for infinity is a figure eight, which in itself contains the knowledge that the end and the beginning are one and the same, that life and death circle back on themselves, that the continuous journey has no end—the wheel of the dharma. It is one symbol that sparks instant recognition just by its being, a sign that we can claim for ourselves.

Perhaps this spark occurred on such a beach thousands of years ago, when we were given the symbol by the tides as an acknowledgment of and a reassurance about life itself. Then, as now, it speaks to our innate understanding of the nature of our being. After this photograph was made, high tide came and reclaimed it.

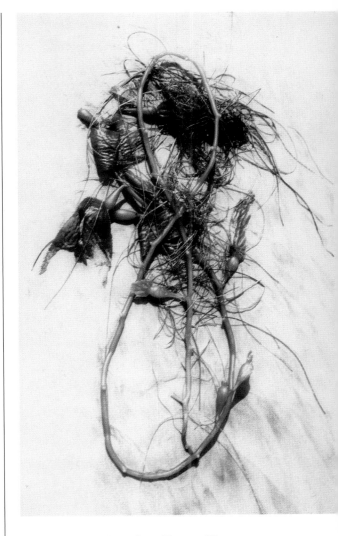

Infinity on the beach at Torrey Pines, washed up at low tide, swept back by high tide, 1996. *Canon EOS 1N 35mm SLR, 35mm lens, Ilford Delta 400 film. Exposure: f/8 at 1/60 second.*

The exposure reading was made from the sand, then was compensated plus two stops to "white it out" in the film. This raised the recorded contrast and created a graphic rendition of the seaweed.

107

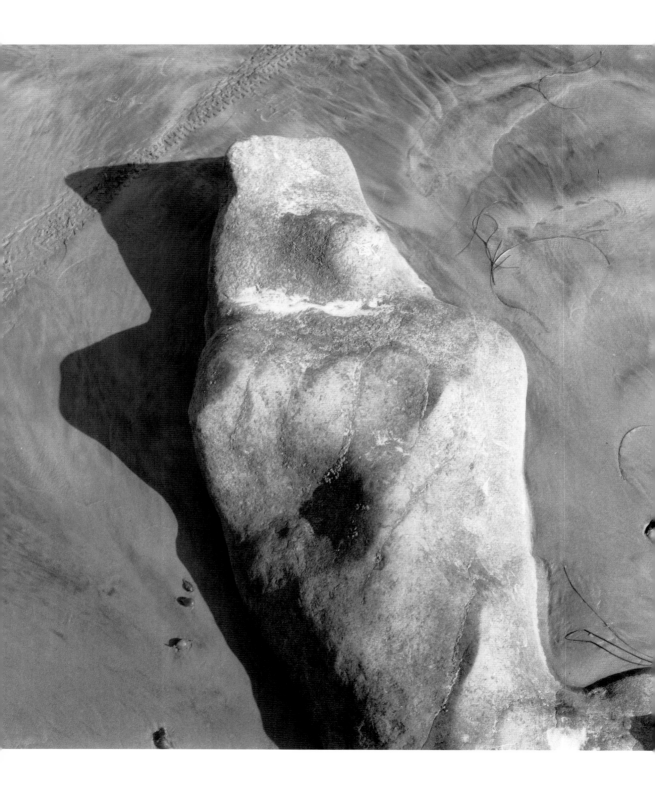

I have always been intrigued by sculpture and how form intersects space and interacts with light. Indeed, one sculpture set, Michelangelo's slaves, seen in the Academia in Florence in the mid-1970s, gave me one of my first art shocks. I remember walking through the crowd and coming upon the sculptures—the figures emerged from the rough rock, freeing themselves from matter and being held by it at the same time. These pieces revealed to me just what the inspired hand of creation can do; how materials can be formed and shaped to reveal the human spirit. I stood there stunned, in awe of the genius of the man and its manifestation in his work.

I now see much of what is around me as a form of sculpture. Buildings, cars, roads, construction sites—all seem to be a sometimes sad commentary on what we choose to mold with our hands as extended through our machines. Their placement may seem accidental, but I see it as an integral part of how we've chosen to shape our world.

I also look at nature as a form of sculpture, but one that shows a divine hand. Trees, rock shapes, the way sand is blown by the wind, the intricate pattern of a leaf, the mountains and their uplifted strata, all there to inform us about the marvel of our natural home.

The two get mixed at times—the hand of humanity and that of nature—and we feed back what we have received from the natural world into our own art. This rock, shaped by the wind, waves, and sand, evokes for me the massive sculptures of Rodin—in particular, his powerful sculpture of Balzac. Through this image, I can feel the power and strength of imagination gained from nature and relive that moment when I stood in awe of Michelangelo's work some twenty-five years ago.

Balzac on the beach, Torrey Pines State Beach, California, 1996. *Rollei 2.8E (medium format, 120 film), Ilford Delta 100 film. Exposure: f/8 at 1/125 second.*

The exposure reading was taken off the highlight on the rock with a Sekonic spot meter; the reading was f/16 at 1/125 second. The exposure was compensated plus two stops to f/8 to lighten the scene. A similar exposure would have resulted by taking a reading right from the sand and assigning that the middle-gray value.

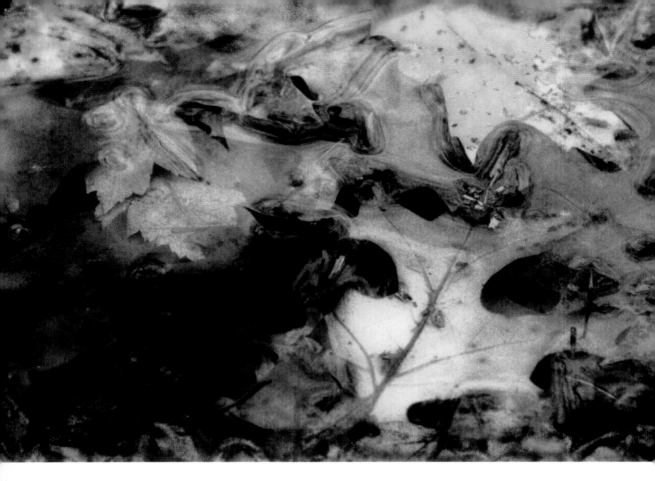

Spring thaw in a pond, outside New Paltz, New York, 1979. *Minolta X-700 35mm SLR, 100mm macro lens, Kodak 2475 film rated at EI 640. Exposure: f/5.6 at 1/500 second.*

These photographs were made in dim, overcast light, but the fast film allowed me to get a fairly fast shutter speed working with a handheld camera. When working with close-ups, I set the focus on the lens and literally move slowly in and out of the scene until I find the composition I like, then snap the shutter.

I have a very strong childhood memory of lying down in the grass and garden in the backyard and watching the small world go by. I would watch the light come through the leaves, or a column of busy ants, for hours at a time. (This was before the age of TV.) When we get close to subjects, we begin to relate to the world in a different way. We realize that the small can represent the large and that the life around us is made up of millions of small pieces that work together in some fanciful dance.

Photography is eminently suited for exploring the small world, and every camera system has special lenses, close-up filters, lens extenders, and so forth that bring us a view of life that the unaided eye cannot or chooses not to see. Once we begin this exploration, new perceptions are opened to us, as we lose track of the scale of the things we photograph and begin to explore patterns and forms not often seen in the larger world.

I began this study of magical forms by working along stream banks and pho-

tographing the root systems of trees that were revealed by erosion. I was not photographing trees and rocks but opening up to the new environment of design and patterns of the subterranean world. I then found another place where these revelations were available—the surface of ponds and streams just emerging from the winter's freeze.

The images on page 110–111 are from a series made in April in New York's Catskill Mountains. I chose a high-speed, high-grain film to be able to work with a handheld camera in dim forest light and to add texture and grain that would meld the forms together. I printed the first image in many ways—this rendition is made darker around the edges to emphasize the pattern and design of the leaf in the center.

The second image, made in the same series and with the same film and exposure specs, evokes more than pattern and form for me. A narrative, or at least some characters, seems to emerge from the pond. The form on the left evokes a Teutonic knight, with crested helmet, a breastplate of ice, and leaves clustered on the shoulder. The eye socket is empty and blank; from it stretches a creature with an upraised right arm. This may be what the surrealists called "paranoid vision," and this form emerged only after the film was developed—I certainly didn't see it when the photograph was made. Later, I read that Max Ernst and others of his time would make rubbings from wood (in a sense, using the bark or limb as a printing plate), then find forms, shapes, characters, and entire scenes from what they obtained. The same occurred with Edward Weston and his peppers, which to the seeing eye evoke human forms.

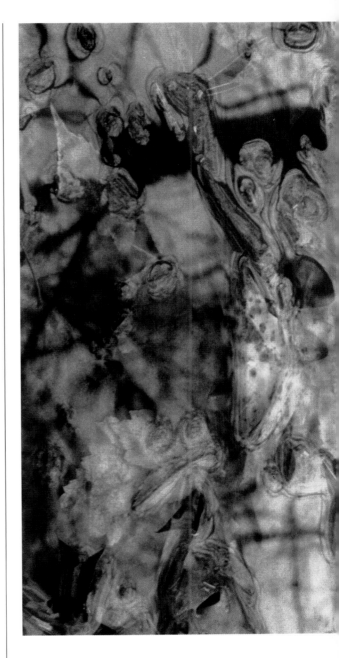

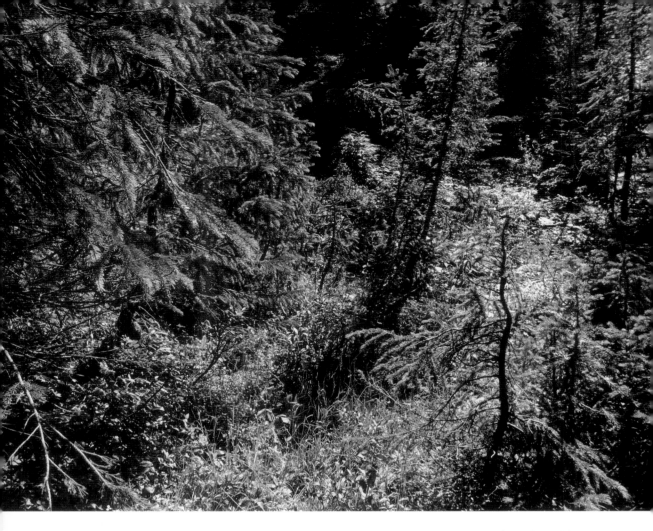

Forest light on the Williams Lake trail, Taos, New Mexico, 1992. *Nikon F3 35mm SLR, 28mm lens, Ilford Delta 400 film. Exposure: f/16 at 1/250 second.*

This was the exposure read out by the camera, which, because of the contrasty light, tended to underexpose the shadow area. The contrast was raised slightly when the print was made by using a #3 grade paper.

Photography is about light—seeing light and determining how it can be translated to film. The literal subject of these photographs is the sense of place where they were made; their meaning to me is the quality of light and tonality they contain. The subjects are incidental.

Our first impression of the world is formed by light. Babies are fascinated by the light that plays through their windows, and they follow it like a moth does a flame. Indeed, if we should meet, our first impressions of each other would be the reflected light we cast from ourselves. The Greeks claimed that light both entered the mind and streamed out of the body through the eyes, that the soul both drew nourishment and emanated light from its core. The Dutch painters depicted light as the manifestation of the word of God.

When I am dazzled by light and have a camera in hand, I begin to think about how I can maximize the moment. My first step is to consider where to make the exposure readings so that I can capture the quality of light. This may or may not be an exposure that captures all the tonal values in the scene. I may also make an exposure that I know will require adjustment when the print is made.

Or I may do everything I can to squeeze every bit of tonality out of the scene.

The literal meaning of the word *photography* is "drawing with light." As such, it gives us a vehicle for immersing ourselves in an appreciation of light, shadow, and form. It can become the extension of our eye that allows us to touch and hold that light and share its wonders with others.

Lifting storm, Green Mountains, Vermont, 1983. *Nikon 8008 35mm SLR, 105mm lens, Kodak Tri-X 400 film. Exposure: f/4 at 1/125 second.*

The exposure reading was made from the center brightness values, which bridged the gap between the dark foreground and the bright background. When the print was made, exposure was added to the sky to bring in more detail and tone.

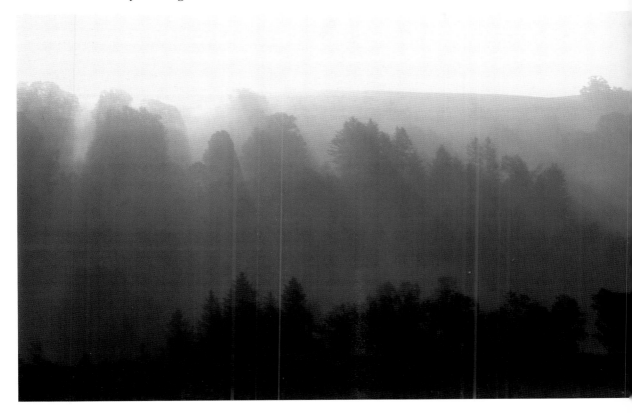

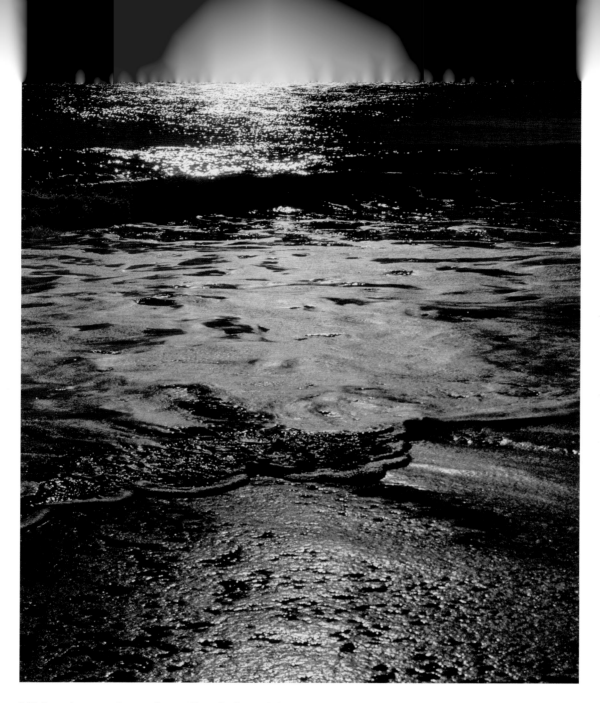

Mild surf at sundown, Jones Beach, Long Island, New York, 1982. *Nikon F3 camera, 24mm lens, Kodak Tri-X 400 film. Exposure: f/11 at 1/125 second.*

The exposure reading was made from the water beyond the breakers, avoiding the spectral highlights, and compensated minus one and a half stops. Although the tonal range of the negative is excellent, the sky needed some darkening, as did the foam in the foreground, when the print was made.

Shadows define form and alter subjects, depending on the time of day. The eye can compensate for contrast by scanning the scene and adjusting to the different levels of light. Film and camera cannot do this and look on scenes with an almost fixed stare. The difference between how we see and how film records a scene can be startling, and learning that difference is key to being able to previsualize results.

I lived in a group house in the 1970s, an artists' shanty with a botanist in the basement, a video madman in the attic (filled with wires and fifty old TV sets lining the walls), and a painter next door. The painter, Julius Vitali, would go out late in the day and photograph oddly shaped shadows, dark forms thrown off from buildings, signs and other man-made objects, and then use the photographs as reference for his work. One of my earliest published articles was about his photography and was titled "Shadowgraphs." Vitali's compulsive and stimulating work got me to look at shadows in a different light—as having a life of their own, ephemeral as that life might be.

Shadows play a key graphic role in many images. They cut into form and reshape it; they obscure detail only to highlight what remains. They contain the unknown and spark our imaginations. What child hasn't peeked in fear from under the covers as the shadows from the moon played across the floor?

The shadows in Joshua Tree National Monument alter the landscape as the day wanes. The piles of boulders, already a study in divine sculpture, change in aspect every minute. They throw longer and longer shadows as the light angles lower in the sky. Walking the trails at such a time is pure visual delight.

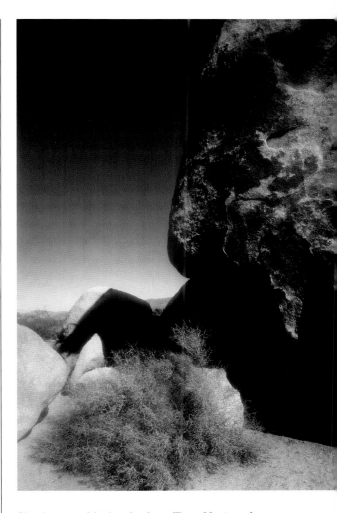

Shadow and light, Joshua Tree National Monument, California, 1993. *Nikon 8008 35mm SLR, Kodak Kodachrome 64 slide film, converted to a black-and-white negative. Exposure: f/16 at 1/60 second.*

All color film can be converted to a black-and-white negative by a custom lab or in your home darkroom. This was a high-contrast lighting condition made even more so due to the nature of slide film and the need to bias exposure for the highlights. Exposure was made from the brightest highlight and opened up one and a half stops.

115

Potential. It's a word that's haunted everyone who's ever gone before a guidance counselor in school. "He or she has so much potential but is not living up to it. If only he or she would apply himself or herself more . . . blah, blah, blah." What was that potential they were always pushing? Was it the potential to explore the mysteries of the world, to hear the music in the wind, to dream about what life held in store? No. It was to toe the line, to follow the rote lessons, to keep quiet and accept an education that denied an inner voice. From what I can see, it hasn't gotten much better today. Music classes are gone; art classes are tracing old patterns at best if at all. This one's for all those who kept their potential to themselves, who understood that what would later blossom was not being taught in school. These autumnal pods contain seeds that await the spring.

Seedpods, Welwyn Estate, Glen Cove, New York, 1997. *Calumet Cadet 4×5 camera, 135mm lens, Kodak T-Max 100 film. Exposure: f/16 at 1/30 second.*

This photograph was made right after a rainstorm, and these early-autumn seedpods glistened with wetness and the diffuse overcast light. I made a spot reading of the pods and made the exposure at plus one stop from that reading. I wanted to be sure that the seeds inside the pods would record, so in essence, I underexposed the brighter areas to have them record with a darker tonal value on film. This was a "straight" print, with no manipulation; in effect, the manipulation was done during the film exposure.

Rock face, Zion National Park, Utah, 1984. *Minolta X-700 35mm SLR, 28mm lens, Kodak Tri-X 400 film. Exposure: f/11 at 1/125 second.*

The exposure reading was made straight from the scene, as the range of values was such that an averaged reading recorded the full scale of tones onto film.

The intensity of life can be felt at any moment we choose. It is a matter of stepping away from the rush of distractions and focusing on the intricacy of design and form around us. How we connect depends on what we allow ourselves to see. When we cede our hearts and minds to commerce, to greed, to false status, we buy into someone else's game—and it's a rigged game at that, one that's intended to draw away our energy and spirit from what is important to us in life.

One way that I plug into that intensity is by focusing on the details of a place and then allowing them to stand in for the place itself or for a sense of design and form or for other forces that the abstraction suggests. I attempt to open myself up to see these things by dropping other matters that may have seemed important, by creating what Zen calls an "empty mind."

But that state of mind cannot be blank— too much experience has filled whatever void I desire. Instead, the shapes and forms that present themselves come to inhabit another plane of thought, and in their recording, I attempt to manifest some spiritual feelings that only they can express. Yes, they are only rocks and trees, but in some way, these images become contemplations; their patterns and tones resonate within me and evoke a deeper appreciation for the mysteries hidden behind the distractions of everyday life.

Rock face, Zion National Park, Utah, 1984. *Minolta X-700 35mm SLR, 28mm lens, Kodak Tri-X 400 film. Exposure: f/8 at 1/125 second.*
This scene showed little variance in brightness values except for the sliver of snow on the rock wall. To raise contrast slightly, one stop was added to the reading (from f/11 to f/8).

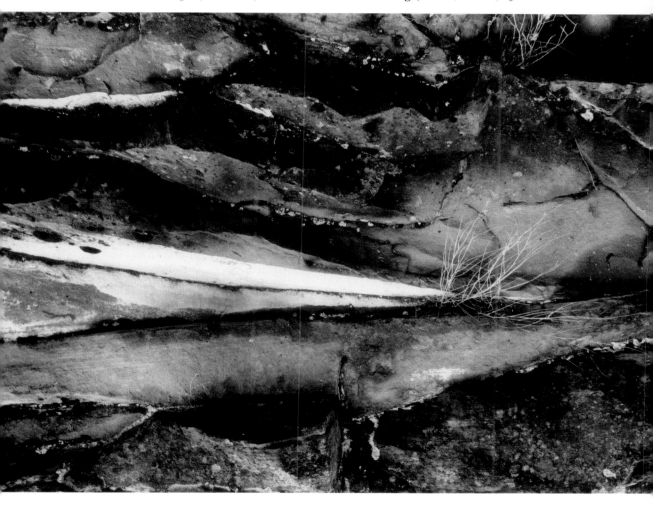

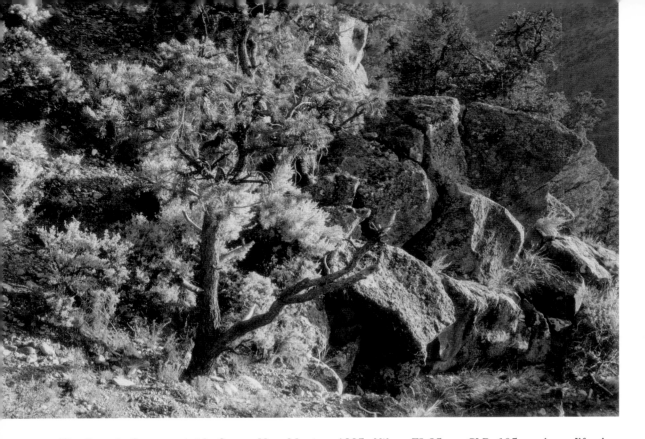

Rio Grande Gorge outside Cerro, New Mexico, 1995. *Nikon F3 35mm SLR, 105mm lens, Ilford Delta 400 film. Exposure: f/11 at 1/250 second.*

A shaft of light coming through the clouds from the setting sun lit up this tree on the cliff face. To capture detail in the brighter and darker areas of the scene, I made a reading from the darker area and closed down the lens one and a half stops. The brighter areas thus became slightly overexposed; I fixed this in printing by using a #1 (lower-contrast) grade paper and burning in the area (adding exposure selectively).

Each of us should find a touchstone, a place where we can go to plug into a creative space, where we feel at home with ourselves and our art. I've found that place in northern New Mexico, my second home. One spot that goes right into my heart is a section of the Rio Grande outside the small town of Cerro, in the Wild and Scenic Rivers area. There, the Rio Grande meets the Red River. The deep valley winds its way past springs and through towering mesas; life struggles and finds its place among huge fallen boulders and rocky cliffs; hawks describe parabolas on the changing sky.

Clouds form in the west and race over the rift; shadows move and change up and down the valley walls.

This photograph was made on the Little Arsenic trail on the westward facing side of the valley. August thunderclouds, miles high, were forming in the distance, allowing shafts of light to dart around the cliff. As the sun lowered, the wind picked up, and the intensity of light created spotlights throughout the vast space. When walking there, I realize that there's no other place I need to be.

Our journey in this book started in this place. That's where we'll end it—on the trail.

RESOURCES

Recommended Reading

Adams, Ansel. *The Negative.* Bulfinch Press, 1981.

——*Photographs of the Southwest.* Bulfinch Press, 1976.

——*The Print.* Bulfinch Press, 1983.

Bullock, Wynn. *The Enchanted Landscape: Photographs, 1940–1975.* Aperture, 1993.

Bunnell, Peter C. *Minor White: The Eye that Shapes.* Princeton University Press, 1989.

Caponigro, Paul. *Masterworks from Forty Years: Photographs by Paul Caponigro.* Photography West Graphics, 1997.

Crawford, William. *The Keepers of Light: A History and Working Guide to Photographic Processes.* Morgan & Morgan, 1979.

Kenna, Michael. *Michael Kenna: A Twenty-Year Retrospective.* RAM Publications, 1994.

Newhall, Beaumont. *The History of Photography from 1839 to the Present.* Bulfinch Press, 1982.

Sexton, John. *Quiet Light: 15 Years of Photographs.* Bulfinch Press, 1990.

Strand, Paul. *An American Vision.* Aperture, 1993.

Stroebel, Leslie, and Richard Zakia. *The Focal Encyclopedia of Photography.* Butterworth-Heinemann, 1993.

For out-of-print books:
A Photographer's Place
PO Box 274
133 Mercer St.
New York NY 10012
212-431-9358

Manufacturers of Products for Black and White Photography

Agfa Division of Bayer Corporation
 (film, paper, chemicals)
100 Challenger Rd.
Ridgefield Park NJ 07660
201-440-2500

Eastman Kodak
 (film, paper, chemicals)
343 State St.
Rochester NY 14650
1-800-242-2424

Fuji Photo Film USA
 (film)
555 Taxter Rd.
Elmsford NY 10523
914-789-8100

Ilford Photo
 (film, paper, chemicals)
70 W. Century Rd.
Paramus NJ 07652
201-265-6000

Konica USA Inc.
 (film)
440 Sylvan Ave.
Englewood Cliffs NJ 07632
201-568-3100

Luminos Photo Corporation
 (paper and chemicals)
25 Wolfe St.
PO Box 158
Yonkers NY 10705
914-965-4800

Internet Resources

Most companies can be found through
http://www.(company name).com

For web pages on black-and-white photog-
raphy, use a search engine like Yahoo and
type in "photography black and white" in
the keyword search box.

For books on photography, try
Amazon.com

Magazines

The Camera Arts
Outdoor Photographer
Outdoor & Nature Photography
Petersen's Photographic
Popular Photography
Shutterbug
View Camera